NATIONAL GEOGRAPHIC

ANGRY BIRDS™

SEASONS

A festive performer is dressed in a vibrant, extravagant costume at Rio de Janeiro's Carnival celebration, the most famous and largest Carnival celebration in the world.

NATIONAL GEOGRAPHIC

ANGRY BIRDS™

SEASONS

A Festive Flight Into the World's Happiest Holidays and Celebrations

AMY BRIGGS ★ FOREWORD BY PETER VESTERBACKA

NATIONAL GEOGRAPHIC

Washington, D.C.

Published by the National Geographic Society, 1145 17th Street N.W., Washington, D.C. 20036

Paperback ISBN: 978-1-4262-1181-2
Reinforced library edition ISBN: 978-1-4262-1286-4

CELEBRATING
‹125›
YEARS

The National Geographic Society is one of the world's largest nonprofit scientific and educational organizations. Founded in 1888 to "increase and diffuse geographic knowledge," the Society's mission is to inspire people to care about the planet. It reaches more than 400 million people worldwide each month through its official journal, *National Geographic*, and other magazines; National Geographic Channel; television documentaries; music; radio; films; books; DVDs; maps; exhibitions; live events; school publishing programs; interactive media; and merchandise. National Geographic has funded more than 10,000 scientific research, conservation, and exploration projects and supports an education program promoting geographic literacy.

For more information, visit **www.nationalgeographic.com.**
National Geographic Society
1145 17th Street N.W.
Washington, D.C. 20036-4688 U.S.A.

For information about special discounts for bulk purchases, please contact
National Geographic Books Special Sales: **ngspecsales@ngs.org**

For rights or permissions inquiries, please contact National Geographic Books
Subsidiary Rights: **ngbookrights@ngs.org**

Cover design: Jonathan Halling; interior design: Nicole Lazarus

Printed in Hong Kong
13/THK/1

Contents

Foreword: CELEBRATE THE SEASONS WITH THE ANGRY BIRDS! 6

Introduction: IT'S PARTY TIME! 8

JANUARY 10

FEBRUARY 22

MARCH 34

APRIL 46

MAY 58

JUNE 70

JULY 82

AUGUST 94

SEPTEMBER 104

OCTOBER 116

NOVEMBER 126

DECEMBER 138

Appendix 152 Glossary 156 Illustration Credits 158 About the Author/Acknowledgments 159

CELEBRATE THE SEASONS WITH THE ANGRY BIRDS!

Imagine a hot August afternoon in the Spanish town of Buñol. Ripe tomatoes fly through the air and hit people. This is La Tomatina festival, where thousands of people participate in a tomato fight—just for fun!

Cherry blossom festivals in Japan attract millions of people to visit parks and admire cherry trees in full bloom. They relax under the trees and enjoy a picnic in good company in the lovely spring weather.

Traditional celebrations follow each other during the year, and sometimes the preparations start well in advance. Festivals and sports events interest people and invite them to join in. This book, born out of the collaboration between Rovio and National Geographic, introduces traditional holidays and festivals from around the world.

Although celebrations vary from country to country and from culture to culture, their purpose is always the same: to rejoice and to spend time with family and friends.

Peter Vesterbacka
Mighty Eagle & CMO
Rovio Entertainment Ltd.

IT'S PARTY TIME!

When the game Angry Birds first came out, all we knew about these birds was that they were very angry at a group of pigs. But then Angry Birds Seasons arrived and revealed a different side to the residents of Piggy Island. Game updates like "Year of the Dragon," "Hogs and Kisses," "Ham o'Ween," and "Winter Wonderham" gave fans a look at the festive side of the pigs and birds. We saw them celebrate holidays like Chinese New Year, Valentine's Day, Halloween, Christmas, and many more. But what about other celebrations? What do holidays in other places look like?

To answer that question, National Geographic has teamed up again with Angry Birds to search for the quirkiest festivals, the happiest holidays, and the biggest seasonal celebrations the world has to offer. In this official companion to the game, *Angry Birds Seasons* shows how people from different corners of the Earth come together to celebrate different occasions—from New Year's Day to April Fool's Day, from the Iditarod to the Olympics, and from Mother's Day to Guy Fawkes Day. Cool customs, dynamite decorations, and festive foods are all part of the mix as the history, the legends, and the traditions of every holiday are explored on each page.

So put on your party hat and get set for a year's worth of the world's best festivals and celebrations with the Angry Birds!

—Amy Briggs
March 2013

Belarusans dance around a fire during a Midsummer celebration.

CELEBRATE JANUARY

Confetti streams down at midnight into New York City's Times Square, an iconic location to ring in the New Year.

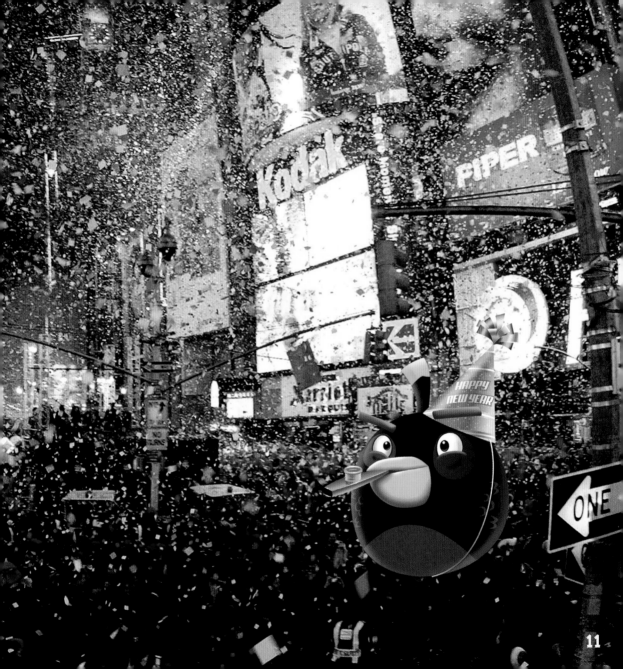

HAPPY NEW YEAR!

Mum's the word!

January 1 is the first day of the year in many countries. The tradition began back in ancient Rome when Julius Caesar introduced a calendar that placed the beginning of the year in January, the month named for the god Janus, the god of beginnings and endings. Centuries later, Christian leaders moved New Year's Day to other dates, but then firmly reestablished the date in January in 1582. Other countries adopted this calendar, and January first became New Year's Day in the Western world.

MUM'S THE WORD!

Not only is New Year's Day a time for looking ahead, but it's also a time for celebration. One of the oldest and biggest celebrations has been held for more than a century in Philadelphia, Pennsylvania—the New Year's Day Mummers Parade. Mummers, quite simply, are entertainers dressed up in colorful costume to celebrate the New Year. Philadelphia began its mumming tradition in the late 17th century. Swedish settlers brought their tradition of visiting friends on December 26 and extended it to the New Year. As the traditions grew and blended, groups would travel from house to house, singing and dancing. By the 1870s, people began wearing costumes and performing. The first official parade sponsored by Philadelphia was in 1901. Today, more than 10,000 people dress up and march in the Mummers Parade to ring in the New Year.

HOLIDATA

DATE: JANUARY 1

LOCATION: WORLDWIDE

FIRST OBSERVED: 45 B.C.

TRADITIONS: MAKING RESOLUTIONS, GOING TO PARADES

GREETINGS: "HAPPY NEW YEAR!"

A marching Mummer celebrates New Year's Day in Philadelphia, Pennsylvania.

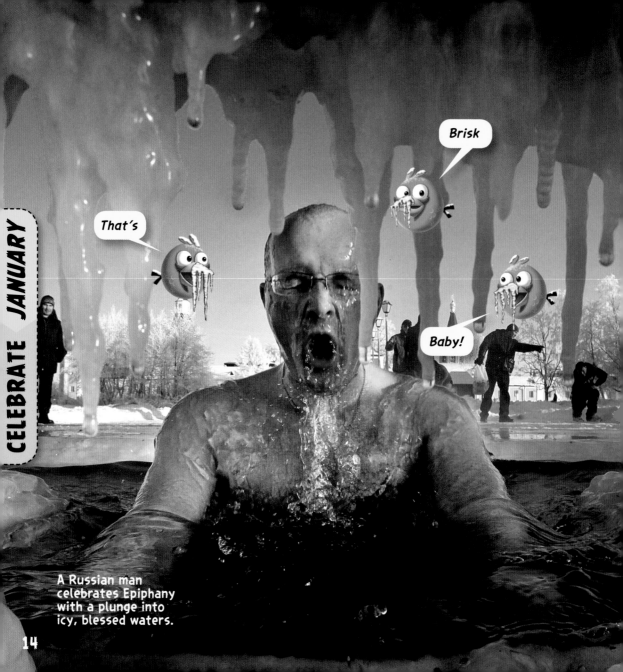

A Russian man celebrates Epiphany with a plunge into icy, blessed waters.

EPIPHANY

"The Twelve Days of Christmas" is more than just a song. It's actually the Christmastide season, which begins on Christmas and lasts 12 days. The season ends on a day called the Epiphany, or Theophany. What the holiday celebrates and when it occurs depends on which tradition one belongs to. To Western Christians, Epiphany falls on January 6 and honors the three kings' visit to the infant Jesus. Many call this holiday "Three Kings Day" and celebrate by eating pastries called "king cakes." These cakes are baked with a prize or a bean inside—whoever gets the prize is king for a day.

TAKING THE PLUNGE!

For Eastern Christians, who follow the Julian calendar, the holiday falls on January 19 and commemorates Jesus' baptism in the Jordan River. Many of the Eastern Orthodox celebrations involve being blessed by water. In some places, like Russia, many take the ritual to a very cold place and plunge into icy waters that have been blessed by priests to cleanse themselves of the previous year's sins. Participants carve cross-shaped holes into frozen lakes and rivers so that they may jump into the frigid water, believing it will strengthen their spirit and body.

HOLIDATA

DATE: JANUARY 6 (GREGORIAN CALENDAR); JANUARY 19 (JULIAN CALENDAR)

LOCATION: WORLDWIDE

FIRST OBSERVED: A.D. 361

WESTERN TRADITIONS: EATING KING CAKES, EXCHANGING GIFTS

EASTERN TRADITIONS: BLESSING OF THE WATERS, JUMPING IN ICE-COLD WATER

FESTIVE FACT
WILLIAM SHAKESPEARE'S PLAY *TWELFTH NIGHT* WAS WRITTEN TO BE PART OF EPIPHANY CELEBRATIONS.

Cattle get gussied up for Pongal in India.

Mooooove over, girls!

PONGAL

Every January, Hindus in southern India celebrate Pongal, the annual harvest celebration. The holiday has been celebrated in India for centuries and is also celebrated in many other parts of the world. Traditions vary from place to place, but the gratitude for and celebration of the harvest remains common to all. In most places, the festival lasts for three days, each one with a special theme and traditions to go along with it.

BOILING OVER

The first day is called *Bhogi Pongal,* and that's when people emphasize looking to the future. Closets are cleaned out and old things thrown away to make room for the new. People decorate the house by drawing colorful patterns called *kolam* with rice flour on the floors. On the second day, called *Surya Pongal,* celebrants cook a sweetened rice pudding called *pongal* (which means "boiling over"). First, milk is boiled in a clay pot and then rice, spices, and jaggery (a sweetener made from sugarcane) are added to the mixture. True to its name, the rice pudding is allowed to cook until it boils over, symbolizing abundance and plenty. On the third day, *Mattu Pongal,* Hindus honor their cattle and thank them for all their hard work. Decorated with flowers, bells, and bright colors on their horns, the cattle are taken to town where they are blessed and also get to eat the rice pudding.

HOLIDATA

DATE: MID-JANUARY, LASTS FOR THREE DAYS

LOCATION: SOUTHERN INDIA, SRI LANKA

ALSO CALLED: MAKAR SANKRANTI, LOHRI

TRADITIONS: HOUSE CLEANING, FEASTING, VISITING FRIENDS

SAYINGS: SHOUTING "PONGAL!" WHEN RICE BOILS

FESTIVE FACT

SEEING THE PONGAL POT BOIL OVER IS SAID TO BRING GOOD LUCK.

17

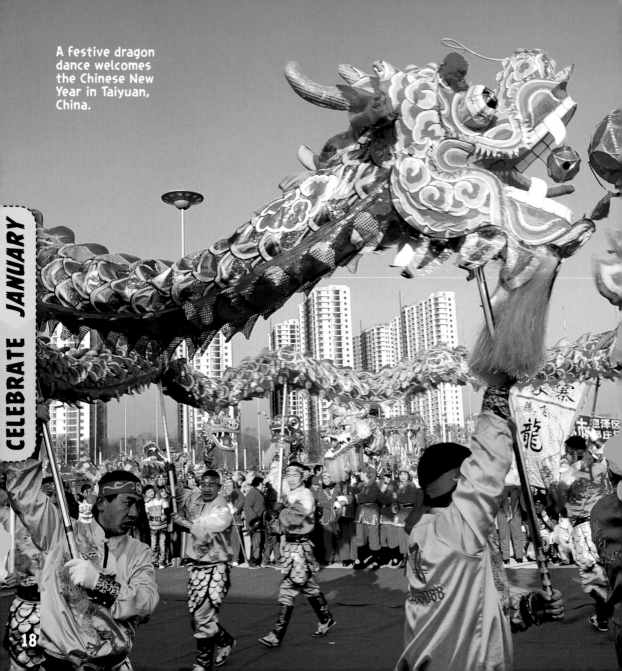

A festive dragon dance welcomes the Chinese New Year in Taiyuan, China.

Enter the Dragon!

CHINESE NEW YEAR

Not only is it the most important of the Chinese holidays, Chinese New Year is also the most spectacular. Celebrating prosperity, wealth, happiness, and health, this 15-day festival consists of great feasts and colorful parades. To celebrate the New Year, families and friends get together on the Chinese New Year's Eve for a great feast that lasts late into the night. As morning and the new year approach, loud firecrackers are lit to frighten away evil spirits. On Chinese New Year's Day, there are parades and public celebrations, many featuring a dragon dance.

WHAT YEAR IS IT?

Unlike the Western New Year, Chinese New Year falls on different dates every year, in late January or early February, because the lunar calendar starts on the first new moon of the year. In the Chinese tradition, each year is ruled by a different animal. There are 12 animals, and their different personality traits will influence people's lives if they are born in that year.

THE CHINESE ZODIAC												
ANIMAL	RAT	OX	TIGER	RABBIT	DRAGON	SNAKE	HORSE	SHEEP	MONKEY	ROOSTER	DOG	PIG
BIRTH YEAR	1948	1949	1950	1951	1952	1953	1954	1955	1956	1957	1958	1959
	1960	1961	1962	1963	1964	1965	1966	1967	1968	1969	1970	1971
	1972	1973	1974	1975	1976	1977	1978	1979	1980	1981	1982	1983
	1984	1985	1986	1987	1988	1989	1990	1991	1992	1993	1994	1995
	1996	1997	1998	1999	2000	2001	2002	2003	2004	2005	2006	2007
	2008	2009	2010	2011	2012	2013	2014	2015	2016	2017	2018	2019
	2020	2021	2022	2023	2024	2025	2026	2027	2028	2029	2030	2031

GASPARILLA PIRATE FEST

Every January, a pirate armada invades Tampa, Florida. But rather than stirring up fear and panic, this annual invasion is cause for citywide celebration. The Gasparilla Pirate Fest is named for Jose Gaspar, a legendary Spanish buccaneer who terrorized the coast of western Florida in the late 18th and early 19th centuries. Few facts are known for sure about this man nicknamed "Gasparilla," but his legend has grown large in Florida folklore.

YO HO HO!

In 1904, the city of Tampa adopted the pirate as their "patron rogue" for a citywide celebration and staged an invasion by "Ye Mystic Krewe of Gasparilla," whose 40 members dressed up as pirates and "captured" the city. The invasion was so popular with the locals that it became a tradition. Today, the krewe invades Tampa aboard the *Jose Gaspar,* a 165-foot-long (50-meter) "pirate" ship, accompanied by a flotilla of much smaller boats. After the mayor presents the pirates with the key to the city, the Parade of the Pirates kicks off the festival, which more than a million people attends. Marching bands, floats, and pirates promenade together, throwing beads and coins to the crowds, who often dress up as pirates themselves.

HOLIDATA

DATE: THE LAST SATURDAY IN JANUARY

LOCATION: TAMPA, FLORIDA, U.S.A.

FIRST OBSERVED: 1904

SIGHTS: THE PARADE OF THE PIRATES, PIRATE SHIPS

SOUNDS: CANNONS, FIREWORKS

Ye Mystic Krewe of Gasparilla invades Tampa, Florida, for Pirate Fest.

Y'arrr!!!

CELEBRATE FEBRUARY

A flower stand sells colorful roses, a traditional Valentine's Day present.

GROUNDHOG DAY

Most weather forecasts only tell you what to expect for the next 24 hours, but on Groundhog Day, North Americans get a six-week look ahead. If a groundhog wakes up from its winter sleep on February 2, emerges from his hole, and sees his shadow, there will be six more weeks of winter. If it's cloudy and he doesn't see his shadow, it means that spring will be early that year. The tradition originated with America's settlers from England and Germany, who would watch badgers and hedgehogs in their old countries. In the colonies, they adopted the groundhog.

WHAT'S THE WEATHER?

Today, the largest Groundhog Day celebration takes place every February in Punxsutawney, Pennsylvania. Local groundhog, Punxsutawney Phil, has been predicting the seasonal forecast for more than a century. Every year, he comes out of his burrow on Gobbler's Knob to look for his shadow. Thousands of people gather in the cold winter morning to hear Phil's prediction, which is announced by the Groundhog Club's Inner Circle, a group of top hat-wearing locals who deliver the news of Phil's prediction to the crowd every year.

I'm all ready to join the Inner Circle!

OTHER WEATHER-PREDICTING GROUNDHOGS

NAME	BALZAC BILLY	BUCKEYE CHUCK	GENERAL BEAUREGARD LEE	SHUBENACADIE SAM	STATEN ISLAND CHUCK	WIARTON WILLIE
LOCATION	ALBERTA, CANADA	MARION, OHIO	LILBURN, GEORGIA	SHUBENACADIE, NOVA SCOTIA	STATEN ISLAND ZOO, NEW YORK	WIARTON, ONTARIO

Punxsutawney Phil predicts
when spring will arrive every
Groundhog Day in Pennsylvania.

SAPPORO

Intricate ice sculptures are also an attraction at the Sapporo Snow Festival.

SNOW FESTIVAL

In 1950, high school students in Sapporo, Japan, built six large snow sculptures in the main town square. Their display was so popular among the townspeople that the city decided to sponsor a snow display every year. In 1955, a local team from Japan's Self-Defense Force built the first massive snow sculpture, and a tradition was born. Since then, it has transformed into a global showcase for the world's finest and biggest snow sculptures. More than two million spectators come every year to see the festival, a winter wonderland that lasts for seven days every February.

THAT'S SNOW BUSINESS!

Today, groups from all over the world design and build unbelievably detailed sculptures, from replicas of the Taj Mahal to a giant Mickey Mouse. Organizers have tons of snow hauled into town for the competition. The festival has expanded to three different locations with different events. Odori Park is where spectators will find hundreds of giant snow sculptures. An ice sculpture competition is also held in the neighborhood of Susinko. The third location is the Sapporo Tsudome, a popular spot for kids because of all the fun things to do: a giant snow maze, snow slides, and lots of food.

HOLIDATA

START DATE: THE FIRST TUESDAY IN FEBRUARY

LOCATION: SAPPORO, JAPAN

FIRST OBSERVED: 1950

TRADITIONS: BUILDING GIANT SNOW SCULPTURES

SIGHTS: SNOW AND ICE SCULPTURES, CROWDS OF PEOPLE

Chocolates have been a popular Valentine's Day gift for a long time.

VALENTINE'S DAY

Today, Valentine's Day celebrates love, but the holiday it originated from wasn't really all that romantic. Valentine's Day began as a feast day for Saint Valentine, a Christian martyr who died on February 14. Little is confirmed about his history, but a common story is that Valentine was a priest who lived in Rome about A.D. 300. The Roman emperor had outlawed Christian marriage ceremonies, but Valentine continued to perform them. The Romans found out, and had him arrested and eventually executed. Before he died, he restored the sight of his jailer's blind daughter and then wrote her a farewell letter signed, "From your Valentine."

BE MINE

Over the years, a strong association with romance and love letters came to flower in the 1400s regarding Saint Valentine's Day. The love letter tradition exploded in England in the 19th century, where factories sprang up to create paper valentines with lace and ribbons. The holiday's popularity continued to grow and new traditions took hold, like giving choco-lates, jewelry, and flowers to your sweetie. But cards still reign supreme: In the United States alone, people buy approximately 160 million valentines each year to give to their sweeties.

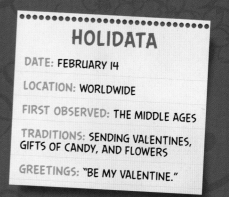

HOLIDATA

DATE: FEBRUARY 14

LOCATION: WORLDWIDE

FIRST OBSERVED: THE MIDDLE AGES

TRADITIONS: SENDING VALENTINES, GIFTS OF CANDY, AND FLOWERS

GREETINGS: "BE MY VALENTINE."

29

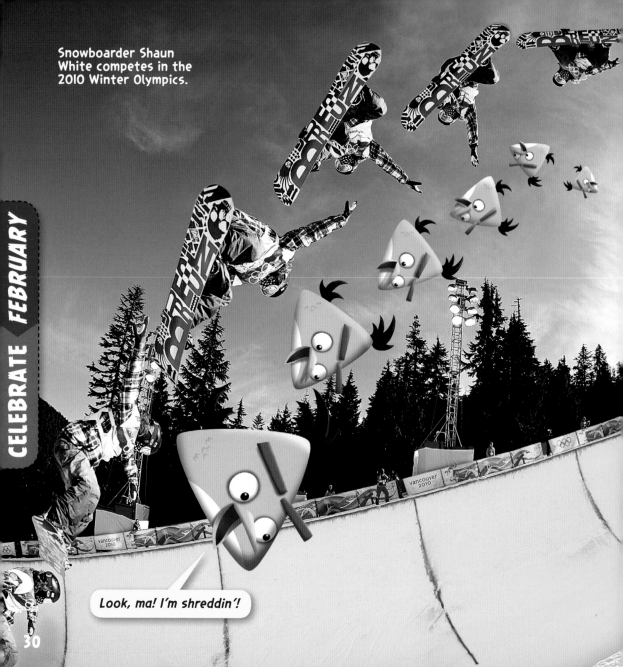

Snowboarder Shaun White competes in the 2010 Winter Olympics.

Look, ma! I'm shreddin'!

THE WINTER OLYMPICS

If you like sporting events that make you shiver, then the Winter Olympics is just your cup of tea. Every four years, a different city hosts the games. The cities need to be snowy, near mountains, and capable of handling the crush of spectators who arrive to watch the amazing athletics out in the cold. But when Mother Nature doesn't cooperate, there are other ways to bring in the snow. In 1964, the Austrian host city Innsbruck didn't have enough white stuff, and the army had to haul it in from out of town.

COMPETITION IN THE COLD

The first Olympic Games were held in 776 B.C., and did not include anything resembling a winter sport. It wasn't until 1924 in Chamonix, France, that the first official Winter Olympic Games were held. Since then, the games have been held every four years (except for 1940 and 1944 due to World War II). Since 1994, the Summer and Winter Olympic Games have been split up and have alternated every two years. The split hasn't hurt the Winter Games' popularity at all: In 2010, three billion people around the world tuned in to see the Winter Games in Vancouver, Canada.

HOLIDATA

DATE: HELD EVERY FOUR YEARS IN FEBRUARY

LOCATION: WORLDWIDE

FIRST OBSERVED: 1924

SIGHTS: SNOW, ICE, OLYMPIC MEDALS

SOUNDS: NATIONAL ANTHEMS

LEAP DAY

You may think it takes the Earth 365 days to go around the sun, but you'd be wrong. It actually takes 365.25 days. But most calendar years are 365 days long. To account for the "surplus" time, a day is added to the calendar every four years. That extra day falls at the end of February, and it's called leap day. Years that have leap days are called leap years. Julius Caesar developed the first calendar that dealt with the problem of an extra day more than 2,000 years ago, and leap years have been observed ever since.

LUCKY LEAP DAY?

Because this day comes so rarely, a number of superstitions are attached to it: In Scotland it's considered bad luck to be born on leap day. And in Greece, it's considered bad luck to marry on leap day. But another popular leap day custom brings good fortune to some couples because it is said that women may propose marriage to men on leap day. A popular but disputed explanation says that in the fifth century, Saint Brigid of Ireland complained to Saint Patrick that women had to wait for men to propose. His solution was to allow women to propose on leap day, which came around every four years.

HOLIDATA

DATE: FEBRUARY 29

LOCATION: WORLDWIDE

FIRST OBSERVED: 45 B.C.

ALSO KNOWN AS: BACHELOR'S DAY

TRADITIONS: WOMEN PROPOSE MARRIAGE TO MEN

FESTIVE FACT

SIR JAMES MILNE WILSON (1812–1880) IS THE ONLY NOTABLE PERSON TO HAVE BEEN BORN AND TO DIE ON FEBRUARY 29.

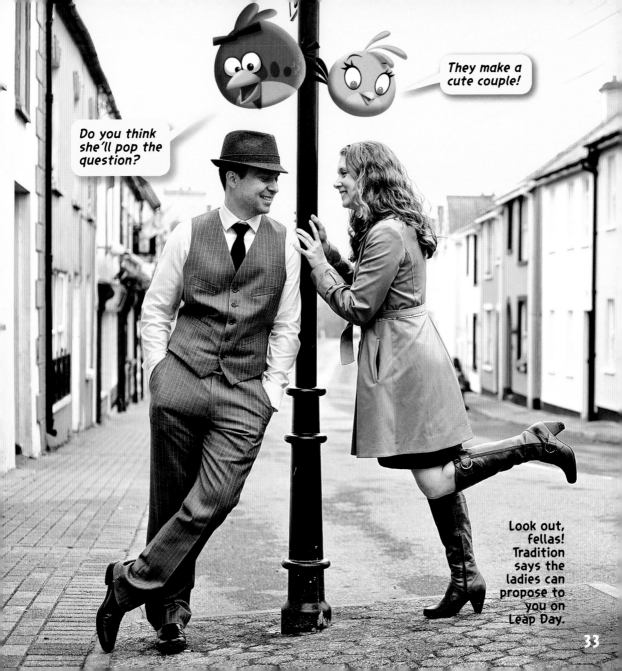

They make a cute couple!

Do you think she'll pop the question?

Look out, fellas! Tradition says the ladies can propose to you on Leap Day.

CELEBRATE MARCH

Masked revelers celebrate Carnevale in Venice, Italy.

CARNEVALE

When mysterious masks, fancy costumes, and colorful parades appear in Venice, it's time for Carnevale, a two-week party filled with delicious foods and grand balls. Both a Christian holiday and a cultural phenomenon, Carnevale is celebrated every year in the weeks leading up to Lent, the 40-day period that starts on Ash Wednesday and ends on Easter Sunday. During this time, many Roman Catholics historically give up rich foods like meat, milk, and cheese. So during Carnevale, people indulge in foods and fun before they go off-limits.

VENETIAN TRADITIONS

Venetians have celebrated Carnevale for centuries. Typically it begins two Saturdays before Ash Wednesday. La Festa delle Marie, a costumed parade through the city, kicks off the festival on the Friday night before the official start of the festival. Parades, jousting tournaments, concerts, and plays are held throughout Carnevale, but the high point comes at the Gran Ballo delle Maschere (Grand Masked Ball) or the Doge's Ball held in a 15th-century palace on Venice's Grand Canal.

CARNIVAL CELEBRATIONS AROUND THE WORLD

NAME	LOCATION	SIGHTS & SOUNDS
MARDI GRAS	NEW ORLEANS, U.S.A.	PARADE FLOATS AND BEADS
CARNIVAL	RIO, BRAZIL	COLORFUL COSTUMES AND SAMBA DANCING
WINTER CARNIVAL	QUEBEC, CANADA	NIGHT PARADES AND SNOW SCULPTURES
PANCAKE DAY	VARIOUS LOCATIONS; ENGLAND	PANCAKE RACES

The competition is festive and fierce in Carnevale's best mask contest.

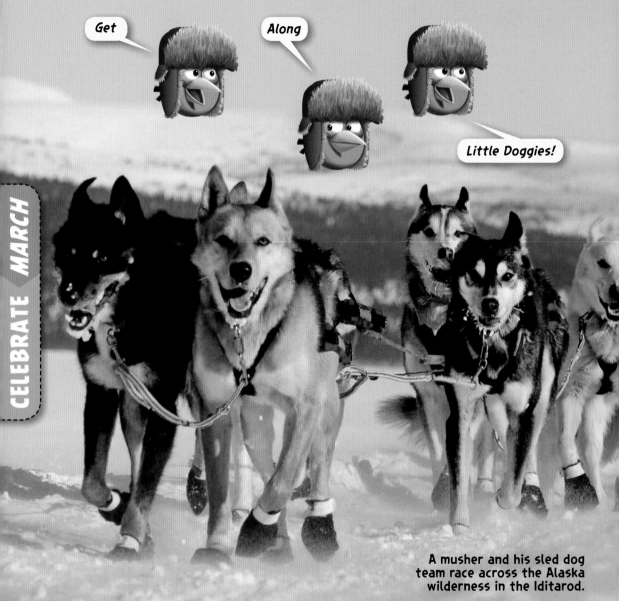

A musher and his sled dog team race across the Alaska wilderness in the Iditarod.

THE IDITAROD

Fans of snowy trails and sled dogs look forward to the annual Iditarod Trail Sled Dog Race every March. In this grueling 1,150-mile (1,690-kilometer) race, mushers (aka the sled drivers) and their teams of 12 to 16 dogs race along the historic trail that connects Anchorage to rural Nome, Alaska. Every dog must have a clean bill of health to enter. Vets are on hand to help out if any animals are injured or become sick during the race.

MUSH!

The Iditarod Trail first came into heavy use in the early 20th century, when settlers came to Alaska looking for gold. Sled dogs became the most popular way to travel. The modern Iditarod began in 1973, as a way to commemorate an important journey that took place in 1925. A diphtheria epidemic was raging in Nome, and the closest source of medicine was in faraway Anchorage. A team of 20 mushers and 150 dogs worked together to deliver the medical supplies in just 6 days. Today, the mushers and their mutts are closing in on that record: The current fastest time was set in 2011, at 8 days, 19 hours, and 46 minutes.

HOLIDATA

STARTING DATE: THE FIRST SATURDAY IN MARCH

LOCATION: ANCHORAGE TO NOME, ALASKA, U.S.A.

FIRST RUN: 1973

SIGHTS: SNOWY TRAILS AND SLED DOGS

SOUNDS: PANTING DOGS

Everyone joins in the "wearing of the green" at this Saint Patrick's Day Parade in San Francisco, California.

Top of the mornin' to ya!

SAINT PATRICK'S DAY

Every March 17, people all over the world don green clothing, go to parades, and eat corned beef and cabbage, all in honor of Saint Patrick, the patron saint of Ireland. Celebrated for more than a thousand years, Saint Patrick's Day is the saint's feast day, which commemorates the day he died in the fifth century. It is both a holy day and a national holiday in Ireland, and its celebration has spread all around the globe—the United States, Canada, Australia, Japan, Singapore, and Russia. Celebrations include big parades and special dinners. In Chicago, Illinois, the Chicago River is dyed green for the day!

HOLIDATA

DATE: MARCH 17

LOCATION: IRELAND, NORTH AMERICA, AND PLACES WITH LARGE IRISH POPULATIONS

FIRST OBSERVED: FIFTH CENTURY A.D.

SIGHTS: SHAMROCKS, GREEN CLOTHES, PARADES

SOUNDS: BAGPIPES AND DRUMS

BEHIND THE SHAMROCK

Born in Britain, Saint Patrick first came to Ireland as a kidnapped slave. He escaped his captors six years later and returned to Britain, became a Christian bishop, and then returned to Ireland to teach people his religion. One legend claims he converted 12,000 people in one day. More popular stories grew around Patrick's legacy. One of the most popular is that he drove all the snakes out of Ireland. There aren't snakes in Ireland today, but many scientists believe there were never any to begin with.

HOLMENKOLLEN SKI FESTIVAL

Just looking down from the top of the towering Holmenkollen Ski Jump in Oslo, Norway, would make most people dizzy. After being renovated in 2008, this iconic steel landmark stands almost 200 feet (60 meters) tall and is at the center of one of Norway's oldest celebrations, the Holmenkollen Ski Festival. Held almost continuously since 1892, this three-day celebration of Nordic sports attracts tens of thousands of fans—including the Norwegian royal family.

HIGH-FLYING HOLMENKOLLEN

Invented in Norway in 1808, ski jumping is a sport in which skiers speed down a ramp, then launch into the air, and soar as far as they can before landing. The first official ski jump competition was organized in Oslo in 1866, and then years later in 1892, it was moved to the Holmenkollen (the hill had better snow), where it's been held ever since. The first festival featured a cross-country skiing race as well as a ski-jumping competition (almost three-quarters of the participants fell that year). The festival has only been canceled a few times—once in 1898 and then during World War II. Today, fans show up for the whole weekend—some even camping out in tents along the ski trails.

HOLIDATA

START DATE: MID-MARCH

LOCATION: NORWAY

FIRST OBSERVED: 1892

SIGHTS: FLYING SKIERS

SOUNDS: CHEERING CROWDS

FESTIVE FACT
THE HOLMENKOLLEN SKI JUMP
IS MADE OF 100 TONS OF STEEL.

The crowd looks on during the Nordic World Ski Championships at the Holmenkollen Arena in Oslo, Norway.

Look out below!

Hanami, here I come!

A group of Japanese women capture the cherry blossoms' beauty with their cameras.

CHERRY BLOSSOM FESTIVAL

As winter gives way to spring, the cherry trees in Japan begin to bloom. Hanami, which means "flower viewing," is the annual Japanese tradition of seeing these beautiful flowers during the short time in which they are blooming. It is a tradition to take a picnic lunch to popular hanami spots and eat with friends and family under the trees while enjoying the fluffy, pink view.

HANAMI HISTORY

The tradition is said to have begun in the late eighth century. In its early years, nobles and royalty enjoyed the flowers in the royal gardens, but the custom spread to the masses by the 1600s, and continues to this day. Several cities host cherry blossom festivals, which take place between March and May, depending on their location. One of the most famous is in the Nara Prefecture where more than 30,000 cherry trees bloom on the slopes of Yoshino-yama, a mountain considered to be one of the best viewing spots. It's said the blossoms have been blooming there for more than 1,300 years.

FESTIVE FACT
IN 1912, THE MAYOR OF TOKYO GAVE THE UNITED STATES 3,000 CHERRY TREES AS A SHOW OF FRIENDSHIP.

HOLIDATA

DATE: MARCH THROUGH MAY

LOCATION: JAPAN

FIRST CELEBRATED: CIRCA EIGHTH CENTURY A.D.

SIGHTS: BLOOMING CHERRY TREES

SMELLS: FRAGRANT CHERRY BLOSSOMS

A bright bonfire burns on Walpurgis Night in Sweden.

APRIL FOOLS!

The first of April is one day when practical jokes and pranks reign supreme. The holiday's origins are a bit murky, but many believe that it evolved out of changing traditions surrounding the start of a new calendar year. For many centuries in Europe, the year had traditionally begun in the spring. When the Gregorian calendar was adopted in the 16th century, the beginning of the year was moved back to January. But not everyone observed the shift, and the people who clung to the old ways were teased and called "April fools." As the years passed, a new custom evolved into poking fun at everybody.

BIG JOKES

Today, most people play small jokes on their friends and family: a whoopee cushion here, a short-sheeted bed there. But larger organizations got in on the fun, too. In 1957, a British TV "documentary" aired, which showed Swiss farmers harvesting spaghetti from trees; many viewers were fooled and called the BBC to see where they could purchase a spaghetti tree. In 1996, the fast-food chain Taco Bell took out a full-page newspaper ad saying that it had purchased the Liberty Bell and renamed it the "Taco Liberty Bell." Thousands of worried people called the U.S. National Park Service only to find out it was all just a joke.

FESTIVE FACT
IN FRANCE, A COMMON APRIL FOOLS TRICK IS TO TAPE A PAPER FISH TO SOMEONE'S BACK.

I'll be the foolingest feathered fellow who ever pulled a prank!

On April 1, 1957, many British TV viewers were fooled by the BBC's Swiss spaghetti tree hoax.

The Easter egg hunt is a fun part of many Easter celebrations.

EASTER

If you're seeing colorful eggs, chocolate bunnies, and blooming flowers, then it must be time for Easter, the most important holiday in the Christian faith. On this day, Christians celebrate Jesus Christ's resurrection, or rising from the dead, and teach that it brings new, everlasting life to those who believe in him. Easter Sunday is the end of Lent, the 40-day season of penance, and the holiday falls on the first Sunday following the first full moon in spring.

EGGS AND BUNNIES

Every year, children look forward to the visit of the Easter Bunny, who brings candy and hides Easter eggs. Both eggs and rabbits have long been symbols of new life and a part of many cultures' spring festivals. Ancient Persians and Egyptians decorated eggs as part of their spring festivities, and Christians later adopted the custom. Pagan Germans associated rabbits with their spring goddess Eostra and her festival. As Christianity spread throughout Europe, ancient customs blended with Easter customs, and the Easter Bunny was born. When German immigrants settled in Pennsylvania in the 1700s, they brought the Easter Bunny with them, and the custom spread across the United States.

EASTER BASKET ESSENTIALS	
	WHERE IT COMES FROM
CHOCOLATE BUNNIES CANDY	ORIGINATED IN GERMANY; BECAME POPULAR IN THE U.S. IN THE 1890S
JELLY BEANS	RELATED TO THE CLASSIC TREAT TURKISH DELIGHT; ASSOCIATED WITH EASTER IN THE 1930S BECAUSE OF THE EGG SHAPE
MARSHMALLOW CHICKS	FIRST PRODUCED IN THE 1950S; NOW OVER 700 MILLION ARE SOLD EVERY EASTER

PASSOVER

One of Judaism's most important holidays, Passover celebrates the Jews' escape from Egyptian slavery more than 3,000 years ago. According to the Hebrew Bible, God commanded the prophet Moses to tell the Egyptian pharaoh to free the Jewish slaves. The pharaoh refused, and ten horrible plagues befell Egypt. The last—and most terrible—was the death of every family's firstborn son. To keep their sons safe, the Jewish people marked their doors with lamb's blood, so that the angel of death would "pass over" their homes. After this final plague, the pharaoh relented, and Moses led his people out of bondage back to their ancestral home.

RITUALS OF REMEMBRANCE

Lasting a week, Passover is observed with many important rituals. One of the most important is replacing all leavened products, like bread, with matzo, a flatbread that reminds Jewish people of the flight from Egypt. According to tradition, when they were fleeing Egypt, the Jews had no time to wait for bread to rise, so they baked flatbread for the journey. Another tradition, the seder meal, is at the heart of the Passover celebration. Families and friends gather around the table and read the story of Moses from a special book called the *Haggadah*. Everyone eats from a seder plate that holds special foods—each one associated with a certain part of the Exodus story and eaten every year so that all remember the hardships of their ancestors.

HOLIDATA

START DATE: THE 15TH DAY OF THE 7TH HEBREW MONTH (MARCH OR APRIL)

LOCATION: WORLDWIDE

FIRST OBSERVED: MID-13TH CENTURY B.C.

ALSO KNOWN AS: PESACH (HEBREW FOR "PASS OVER")

TRADITIONS: GATHERING WITH FAMILY FOR THE SEDER, EATING MATZO

According to Jewish law, bakers have only 18 minutes to knead, roll, and bake matzo after the flour and water mix.

What did one matzo say to the other?

"You crack me up"

53

Communities often work together to clean up local beaches and parks on Earth Day.

Pitching in for the planet!

EARTH DAY

Earth Day got its start in the 1960s, after an American politician saw how pollution was endangering the planet and its resources. Senator Gaylord Nelson wanted to raise awareness of the problem, so in the fall of 1969, he announced that Earth Day would be celebrated the following spring by having a national "teach-in," or forum for open discussion, with an invitation to the entire nation to get involved. And the nation did: Twenty million people in cities all over the country celebrated the first Earth Day on April 22, 1970.

GLOBALLY GOING GREEN

Since then, Earth Day has spread all over the world. In 1993, the Earth Day Network (EDN) was founded to coordinate the growing number of celebrations worldwide. Today, according to the EDN, more than 174 countries and a billion people are involved in Earth Day activities. People can celebrate Earth Day in a number of ways. Some organize local cleanups of their communities, while others have tree-planting parties. Some communities coordinate their efforts, as when U.S. schoolchildren in Seattle, Atlanta, and Detroit worked together in 2005 to plant more than 4,000 trees in an hour.

HOLIDATA

DATE: APRIL 22

LOCATION: WORLDWIDE

FIRST OBSERVED: APRIL 22, 1970

TRADITIONS: PLANTING TREES, CLEANING UP PARKS, RECYCLING

GREETINGS: "HAPPY EARTH DAY!"

FESTIVE FACT
ON EARTH DAY 2005, THE WORLD'S LARGEST BAKED ALASKA DESSERT WAS PREPARED TO PROTEST DRILLING IN THE ARCTIC.

A woman in a witch costume celebrates Walpurgis Night around a bonfire in northern Germany.

WALPURGIS NIGHT

Beware of Walpurgis Night, the last night for evil spirits to cause trouble before spring arrives in May. Celebrated in northern Europe and Scandinavia, Walpurgis Night falls on April 30—exactly opposite Halloween on the calendar—and is celebrated with bright bonfires and loud songs to keep the baddies away. In Finland, the holiday is called "Vappu" and it's a time for street carnivals. In Sweden, giant bonfires light the night as people gather and sing. In Germany, people dress in costume and play tricks on each other.

A NUN'S TALE

Walpurgis Night is a holiday with dual origins. The oldest ones go back to pagan spring celebrations, which were later combined after the spread of Christianity with celebrations of Saint Walburga. Walburga was an English-born nun who was the abbess of a German monastery. She was made a saint on May 1, 870, for her healing abilities. Because her canonization day and the old pagan spring festivals fell around the same time, they blended and became known as Walpurgisnacht, or Walpurgis Night.

HOLIDATA

DATE: APRIL 30

LOCATION: NORTHERN EUROPE AND SCANDINAVIA

FIRST OBSERVED: CIRCA NINTH CENTURY A.D.

SIGHTS: BRIGHT BONFIRES

SOUNDS: LOUD SINGING

CELEBRATE MAY

Teams of bird-watchers flock to New Jersey every May for the World Series of Birding.

Be on the lookout!

Dancing around the Maypole, like the one in Dalarna, Sweden, is a fun May Day tradition.

MAY DAY

After the cold days and long nights of winter have passed, it's only natural that people want to throw a party. The first day of May—called May Day—is a traditional European celebration of the arrival of spring that has been observed for centuries. Some say the holiday originated in the ancient Roman festival dedicated to Flora, the goddess of spring. As the Roman Empire spread throughout Europe, the spring festival spread to all the lands they had conquered, and by the Middle Ages, May Day celebrations were everywhere.

DANCING ROUND THE MAYPOLE

Today, May Day celebrations remain popular, especially in England. The holiday's most enduring tradition is the maypole—a pole often more than 100 feet (30.5 meters) tall that is hoisted in the town square. Ribbons stream down from the top of the pole, and dancers weave them into beautiful patterns as they dance around the maypole. In many towns, people crown a May Queen, who then presides over a party filled with dancing, music, and flowers. As May Day celebrations evolved, they became associated with working people, and many today also celebrate the holiday as Labor Day.

FESTIVE FACT

IN 2010, THE GERMAN TOWN OF EICHERLOH ERECTED THE WORLD'S TALLEST MAYPOLE, WHICH WAS MORE THAN 187 FEET (57 METERS) TALL.

HOLIDATA

DATE: MAY 1

LOCATION: WORLDWIDE, ORIGINATED IN EUROPE

FIRST OBSERVED: CIRCA 45 B.C.

SIGHTS: MAYPOLE DANCING, MAY QUEENS

SOUNDS: FESTIVE MUSIC

CINCO DE MAYO

Break out the maracas, the mariachi music, and the Mexican flag because it's time for Cinco de Mayo! Cinco de Mayo (which means "the fifth of May" in Spanish) commemorates the Mexican defeat of France at the Battle of Puebla in 1862. French Emperor Napoleon III had sent his forces to Mexico to take over the former Spanish colony, but General Ignacio Zaragoza led the outnumbered Mexican militia and put a smackdown on the invaders. (Even though Zaragoza did win this battle, Mexico lost the war. Three years later, it would regain its independence.)

May I cut in?

FIESTA!

Today, Cinco de Mayo celebrations in Mexico are found in the state of Puebla, the place where the victory occurred. Customs there include military parades, battle recreations, public concerts, and street festivals. Originally, Cinco de Mayo was a regional holiday. But the holiday has grown in popularity in the United States, where it not only commemorates the historic victory, but also is a celebration of Mexican culture. It gained a foothold in the 1950s and 1960s, when Mexican Americans embraced the holiday as a source of ethnic pride.

HOLIDATA

DATE: MAY 5

LOCATION: PUEBLA, MEXICO; UNITED STATES

FIRST OBSERVED: CIRCA 1860S

SIGHTS: MEXICAN FLAGS, MEXICAN DANCING

SOUNDS: MARIACHI MUSIC, FESTIVE PARADE MARCHING MUSIC

FESTIVE FACT

MANY PEOPLE CONFUSE CINCO DE MAYO WITH MEXICO'S INDEPENDENCE DAY, WHICH IS ACTUALLY SEPTEMBER 16.

Cinco de Mayo celebrations often feature traditional Mexican folk dances, like the Jalisco style shown here.

You lookin' for me?

WORLD SERIES OF BIRDING

If you're looking for Blue Jays, Cardinals, or Orioles, better get yourself over to the World Series. But don't go to a baseball diamond, head to Cape May, New Jersey, for the annual World Series of Birding held every May in the Garden State. Every year at midnight on the second Saturday in May, the World Series of Birding begins. Teams have only 24 hours in which to identify—by sight or by sound—as many birds as they can.

BIG BIRD BASH

The New Jersey Audubon Society has hosted this event since 1984, when just 13 teams took part. Now more than 100 teams regularly sign up to engage in some healthy competition while raising money for bird conservation. Players can choose different levels of competition, each one with a different top prize.

WORLD SERIES ALL-STAR BIRDS: MOST LIKELY TO BE SPOTTED		
THE BIRD	THE LOOK	THE SOUND
MALLARDS (DUCKS)	MALES HAVE GREEN HEADS; FEMALES ARE MOTTLED BROWN	FEMALES: LOUD QUACKS MALES: A QUIETER, SHORT CALL
MOURNING DOVES	PLUMP BUFF-BROWN BIRDS WITH LONG POINTED TAILS	COOING: *COO-OO, COO COO*
NORTHERN CARDINALS	CRESTED SONGBIRD; MALES ARE BRIGHT RED; FEMALES PALE BROWN	SONGS: A SERIES OF WHISTLES THAT SOUND LIKE *BIRDIE BIRDIE BIRDIE*
AMERICAN GOLDFINCH	SMALL FINCHES WITH YELLOW FEATHERS IN THE SPRINGTIME	SONGS: TWITTERS AND WARBLES THAT LAST FOR SEVERAL SECONDS

A good pair of binoculars is essential viewing equipment for the World Series of Birding.

My mom's da bomb!

In the United States, Mother's Day became a national holiday in 1914.

MOTHER'S DAY

Mother's Day celebrations are found on every continent over the world, with vibrant traditions to honor mothers. In France, la Fête des Mères (which means "Mothers' Festival") is celebrated on the last Sunday in May. In Thailand, Mother's Day is celebrated on August 12, the current queen's birthday, and children give their mothers white jasmine flowers, a symbol of maternal love.

THANKS, MOM!

In the United States, there have been Mother's Day celebrations dating back to the 19th century, but it didn't become an official holiday until 1914. A woman named Anna Jarvis came up with the idea for Mother's Day in 1908. She worked for six years lobbying Congress and finally succeeded. The holiday is observed every year on the second Sunday in May. American families celebrate Mom a number of ways—making cards, giving flowers or gifts, and serving her breakfast in bed.

FESTIVE FACT
IN THE UNITED STATES, PEOPLE SPEND ABOUT $16 BILLION TOTAL ON GIFTS FOR MOM EACH YEAR.

HOLIDATA

DATE: SECOND SUNDAY IN MAY

LOCATION: UNITED STATES

FIRST OBSERVED: 1914

TRADITIONS: MAKING CARDS, GIVING FLOWERS OR GIFTS, SERVING BREAKFAST IN BED

GREETINGS: "HAPPY MOTHER'S DAY"

Eyes

CHEUNG CHAU BUN FESTIVAL

The sleepy Chinese fishing village of Cheung Chau is located on an island about 7.5 miles (12 kilometers) south of Hong Kong. Most of the time, it's a quiet place—except when the annual spring Bun Festival rolls around. Thousands of people flock to the island to witness colorful parades, hear happy music, and eat delicious lucky dumplings.

On

TOWERS OF BUNS

Held every year, the Bun Festival happens from the fifth to the ninth day of the fourth lunar month (between late April and mid-May). Festivities include parades, costumes, and opera performances, but the most popular attraction is the Bun Scramble. In front of the temple of Pak Tai, the Taoist god of the sea, tall towers standing 45 feet (14 meters) high are made of steel scaffolding and covered with thousands of lucky steamed buns. At midnight on the last day of the festival, people traditionally scrambled up these towers to grab as many buns as possible. Safety concerns led to the races being canceled in 1978, but the tradition was revived in 2005. Now competitors must wear harnesses and take courses in climbing before they can compete. The winner is the person who can collect the most buns in three minutes. At the very end of the festival, the buns are blessed and handed out to everyone.

HOLIDATA

DATE: STARTS THE FIFTH DAY OF THE FOURTH CHINESE MONTH (LATE APRIL TO MID MAY)

LOCATION: CHEUNG CHAU, CHINA

FIRST OBSERVED: CIRCA 1890s

SIGHTS: TOWERS OF STEAMED BUNS

SOUNDS: BUN TOWER CLIMBERS AND CHEERING CROWDS

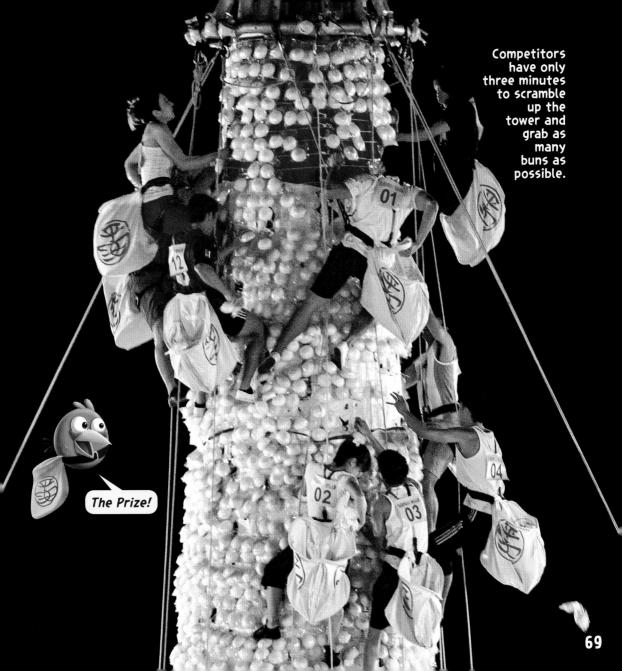

Competitors have only three minutes to scramble up the tower and grab as many buns as possible.

The Prize!

69

CELEBRATE *JUNE*

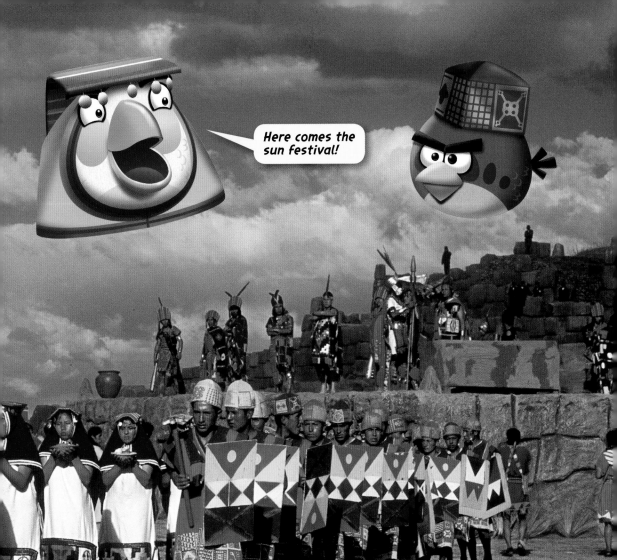

Here comes the sun festival!

In Cusco, Peru, a parade of sun maidens and warriors celebrates the winter solstice festival, called Inti Raymi.

FATHER'S DAY

Every June, American families celebrate Father's Day on the third Sunday of the month. In the mid-20th century, the most popular gifts for dads were neckties, hats, socks, pipes, golf clubs, and greeting cards. Today, people still buy greeting cards but they're more likely to celebrate with trips to sporting events, backyard barbecues, dinner at a restaurant, and gift cards.

A DAY FOR DEAR OLD DAD

Activists only had to work for six years to make Mother's Day a national holiday, but it took a lot more time for Dad to get his day recognized nationally. Mrs. Sonora Dodd of Spokane, Washington, is credited with coming up with the idea for Father's Day, first celebrated in her state in 1910. Dodd's widowed father had raised her and her siblings after her mother's death. As she sat listening to a Mother's Day sermon in 1909, it occurred to her that fathers needed recognition too. She worked with her minister to spread the holiday throughout Washington State and then throughout the country. It took 58 years for Father's Day to become a national holiday in 1972.

My dad is so rad!

TOP TREATS FOR DAD

THE TREAT	THE FACTS
1. GREETING CARDS	93 MILLION GIVEN EACH YEAR
2. GOING OUT TO DINNER	50 MILLION DINNERS ARE CELEBRATED WITH DAD
3. CLOTHING	42% OF SHOPPERS BOUGHT CLOTHES (NO WORD ON HOW MANY TIES)
4. GIFT CARDS	$1.7 BILLION SPENT SO DAD CAN TREAT HIMSELF
5. BOOKS	ABOUT 25% GOT DAD SOMETHING TO READ

As of 2013, there are more than 70 million dads in the United States.

A team of rowers work together
in the annual Dragon Boat Race
held in Foshan City, China.

DRAGON BOAT FESTIVAL

Long, sleek, and speedy, Chinese dragon boats have been racing for more than 2,000 years. The Dragon Boat Festival happens every year on the fifth day of the fifth lunar month, and commemorates the death of the Chinese poet Qu Yuan (343-278 B.C.), who drowned himself in the Milo River. In the story, local townspeople tried to save him, but they were too late. To keep fish and evil spirits away from his body, they beat loud drums and threw rice dumplings in the water. Every year, on the day of his death, they hold the races to honor his memory.

HOLIDATA

DATE: THE FIFTH DAY OF THE FIFTH CHINESE MONTH (EARLY TO MID-JUNE)

LOCATION: CHINA

FIRST OBSERVED: 278 B.C.

SIGHTS: DRAGON BOATS, RICE DUMPLINGS

SOUNDS: BEATING DRUMS

DUELING DRAGON BOATS

Dragon boat races are held throughout China and have spread to many parts of the world—Australia, Great Britain, India, the United States, and Canada to name a few. The boats are adorned with beautifully carved dragon heads up front and ornate dragon tails on the back. Traditional boats measured as long as 100 feet (30.5 meters) and were manned by 80 people. Today, most modern boats are smaller—roughly 40 feet (12 meters) with 20 paddlers. People gather at riversides to watch the races and eat rice dumplings, called *zongzi*.

FESTA JUNINA

Swing

Your

As the weather begins to cool and June draws near in Brazil, people get ready for Festa Junina. This celebration is not just one festival, but three combined. Most popular in northeastern Brazil, these parties honor three saints—Saint Anthony (June 13), Saint John (June 24), and Saint Peter (June 29). Portuguese settlers first brought these European celebrations to Brazil, where locals made them their own. In Europe, these feasts mark the beginning of summer, but in Brazil, they come at the beginning of winter.

CAVORTING IN COSTUMES

Partner!

Festa Junina traditions include bonfires, fireworks, and wearing costumes. Instead of lavish disguises, people dress simply in peasant costumes to celebrate rural life. Men don large straw hats and dress as farm boys and the women paint freckles on their faces and gaps in their teeth. One of the most popular customs of a Festa Junina is the *quadrilha,* similar to an American square dance. In the quadrilha, a couple "gets married" in the course of the dance and then leads the group through the rest. Celebrations go on for hours as people celebrate well into the night.

FESTIVE FACT
TWO BRAZILIAN CITIES—CARUARU AND CAMPINA GRANDE—TRY TO OUTDO THE OTHER FOR THE WORLD'S BIGGEST SAINT JOHN'S FESTIVAL.

HOLIDATA

DATE: JUNE 13, 24, AND 29

LOCATION: NORTHEASTERN BRAZIL

ALSO KNOWN AS: FESTA DE SÃO JOÃO (FESTIVAL OF SAINT JOHN THE BAPTIST)

SIGHTS: PEASANT COSTUMES, DANCING THE QUADRILHA

SOUNDS: ACCORDION MUSIC

Splashy, colorful costumes and lively dancing are part of the Festa Junina festivities.

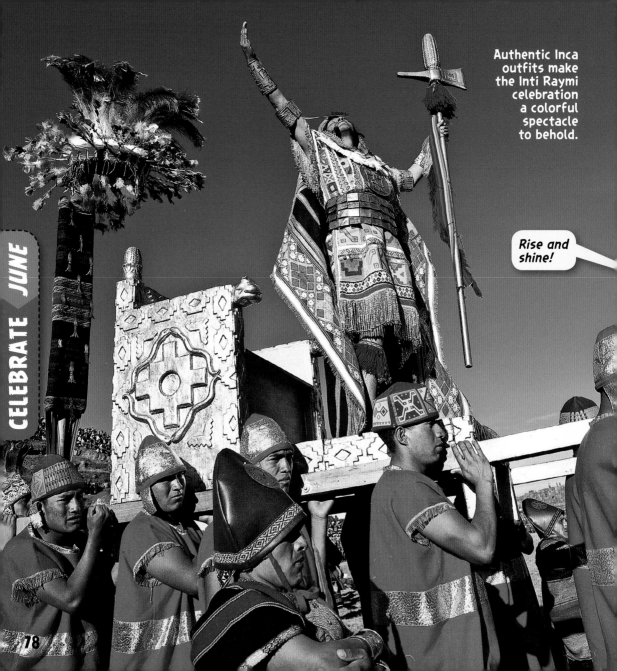

Authentic Inca outfits make the Inti Raymi celebration a colorful spectacle to behold.

Rise and shine!

INTI RAYMI

To the sun-worshipping ancient Inca of South America, the winter solstice marked the beginning of a new year and a new solar cycle. On that day, they performed the rite of Inti Raymi, during which they thanked their sun god. The ancient festival lasted nine days and took place in what is known today as Cusco, Peru. But in 1572, Spanish colonists banned the celebration, and Inti Raymi had to go underground. The festival wasn't revived on a grand scale until 1944.

SUN WORSHIPPERS

Today, Inti Raymi lasts a week, and a reenactment of the ancient sun ceremony takes place on June 24, the winter solstice in South America. Locals play different parts in the ritual; one of the most important is the Sapa Inca, or the emperor, who leads much of the ceremony. Other participants dress up as Inca royalty, priests, and other court officials. They gather in front of the Temple of the Sun to hear the Sapa Inca's invocation before the procession moves to the town center, and then finally ascends the Cusco hillsides to the ancient fortress, Sacsahuaman. There are more speeches, prayers, and sacrifices, all to welcome the return of the sun and to ensure prosperity in the coming year. It's a breathtaking site that attracts hundreds of thousands of people to Cusco each year.

HOLIDATA

DATE: JUNE 24

LOCATION: CUSCO, PERU

FIRST OBSERVED: CIRCA 13TH CENTURY B.C.

SIGHTS: NATIVE INCA COSTUME

SOUNDS: INVOCATIONS TO THE SUN GOD

MIDSUMMER

Midsummer is quite literally the brightest time of the year in Finland. Because Finland is so far north, there are nights where the sun hardly dips down below the horizon. In the northernmost regions of the country, the sun never goes down from around May 17 to July 27. Midsummer celebrates the arrival of these "nightless" nights, whose brightness and light make up for the extreme darkness of winter. Typically held between June 20 and 26, the national celebration marks the official beginning of summer in Finland.

BONFIRES AND SAUNAS

The Finns also call the holiday "Juhannus," a name that comes from John the Baptist, whose saint's day is celebrated around the same time as Midsummer. But Midsummer festivities also date back to pagan times, and one enduring tradition stems from these early celebrations. Building and lighting a giant bonfire, called a kokko, near lakesides or coasts is a popular Midsummer tradition. As midnight approaches on Midsummer Eve, the fires are lit and burn all night.

Many people also celebrate by leaving the cities and going to their country homes with friends and family. Good company, good music, and a good sauna are wonderful ways to celebrate Midsummer.

HOLIDATA

DATE:
THE THIRD WEEKEND IN JUNE

LOCATION: FINLAND

ALSO KNOWN AS: JUHANNUS

TRADITIONS: BONFIRES, STAYING UP ALL NIGHT

GREETINGS: "HYVÄÄ JUHANNUSTA!" (HAPPY MIDSUMMER!)

FESTIVE FACT
MIDSUMMER IS ALSO
A FINNISH FLAG DAY.

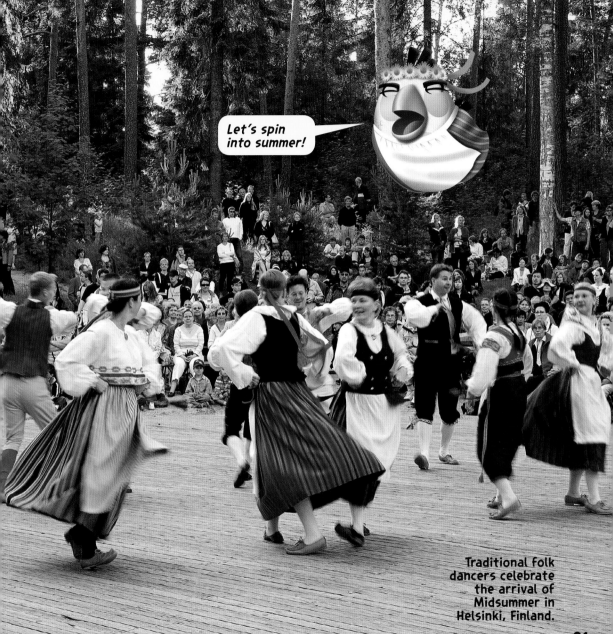

Traditional folk dancers celebrate the arrival of Midsummer in Helsinki, Finland.

CELEBRATE JULY

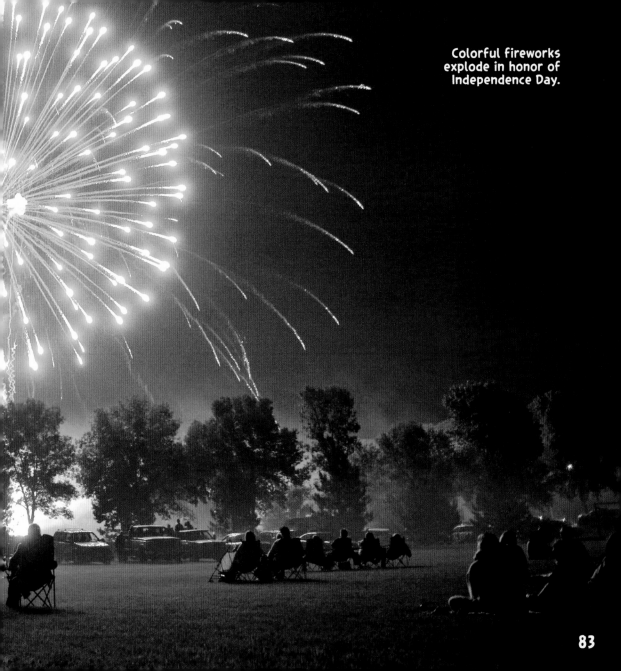

Colorful fireworks explode in honor of Independence Day.

IL PALIO

Fast-paced action, civic pride, and authentic medieval traditions are all part of Il Palio, a festival held every summer in Siena, Italy, since the Middle Ages. Il Palio honors the Virgin Mary through its colorful pageantry, delicious food and drink, and two rollicking horse races around the town square, the Piazza del Campo.

OFF TO THE RACES

Siena has 17 neighborhoods (called *contrade*) that compete against each other in the races. Each *contrada* is named after an animal or a symbol—the giraffe, the tower, the snail, for example—and has its own distinctive colors worn by its jockey. Competition between neighborhoods is fierce, and rivalries can get ugly. (In the past, horses have been drugged and riders kidnapped.) The horse races were first run in 1644, and the contrada with the most wins since then is the Oca neighborhood ("goose" in Italian), which has won 64 times.

The Palio horse races are run annually on July 2 and August 16. The Piazza is turned into a racetrack by covering the perimeter with dirt and placing protective crash pads around the edges. On race day, spectators pack the Piazza and its surrounding buildings to get a glimpse of the thrilling events. The jockeys ride bareback and race at a breakneck pace around the Piazza three times; the races last only about 90 seconds, but the glory lasts forever!

FESTIVE FACT
THE WINNER OF THE PALIO RECEIVES A SILK BANNER PAINTED WITH THE VIRGIN MARY'S IMAGE.

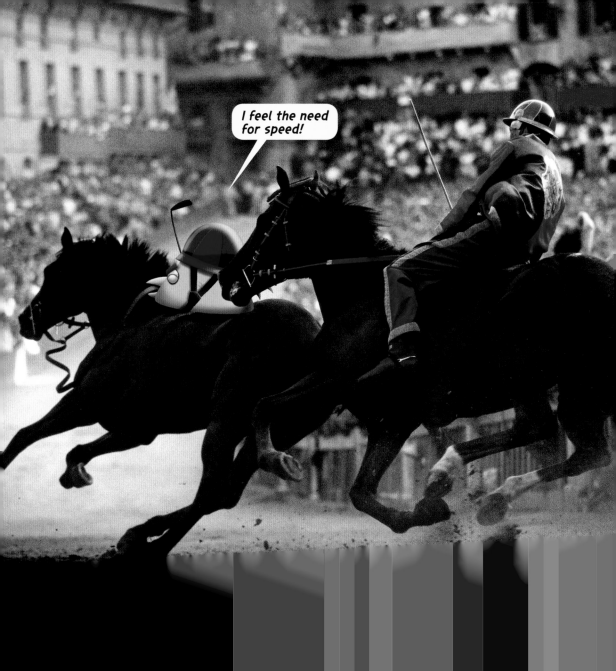

INDEPENDENCE DAY

Strike up the band and light up the fireworks when it's the Fourth of July in the U.S.A.! That's the day that the United States commemorates the signing of the Declaration of Independence and the colonies becoming an independent nation. In the 1700s, England ruled over 13 colonies along the east coast of North America, but the colonists decided they wanted to rule themselves. In 1776, the colonial leaders gathered in Philadelphia, Pennsylvania, to discuss independence. Working with other delegates, Thomas Jefferson wrote the Declaration, which was signed on July 4. Four days later, it was read to a large crowd of people who celebrated by ringing bells and cheering. A new country was born, but it had to win a war before it became completely free.

HAPPY BIRTHDAY, AMERICA!

In a letter to his wife Abigail, John Adams, one of the Founding Fathers, described how he envisioned future celebrations would be: "Pomp and Parade . . . Bells, Bonfires and Illuminations." His foresight was amazing because Americans still celebrate their nation's birthday in these ways today: Parades, fireworks, and backyard cookouts are the most popular ways to celebrate independence.

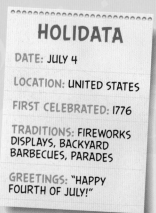

HOLIDATA

DATE: JULY 4

LOCATION: UNITED STATES

FIRST CELEBRATED: 1776

TRADITIONS: FIREWORKS DISPLAYS, BACKYARD BARBECUES, PARADES

GREETINGS: "HAPPY FOURTH OF JULY!"

FESTIVE FACT
IN 1776, ABOUT 2.5 MILLION PEOPLE LIVED IN THE UNITED STATES. TODAY, THERE ARE 311.7 MILLION AMERICANS.

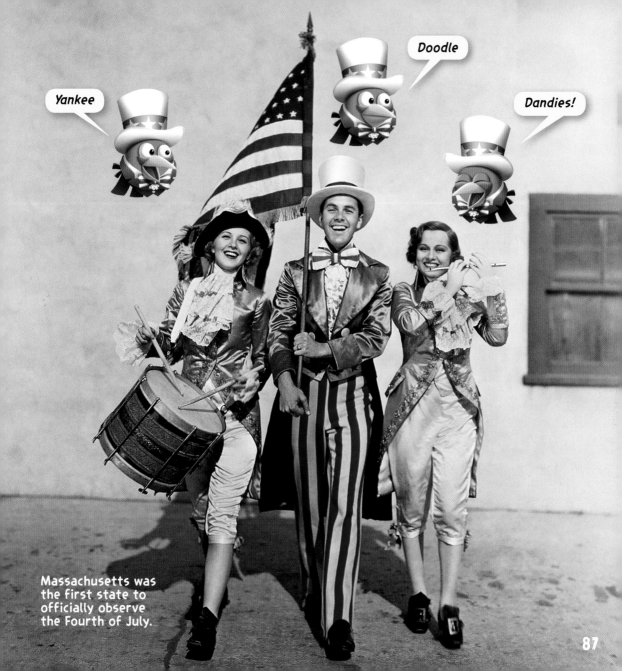

Massachusetts was the first state to officially observe the Fourth of July.

Each running of the bulls lasts only about three minutes.

Look out behind you!

RUNNING OF THE BULLS

One of Spain's most famous events, the Encierro, or running of the bulls, is part of an eight-day festival held in Pamplona in honor of San Fermin, the patron saint of the region. Celebrated every year from July 6 to 14, the fiesta attracts spectators from all over the world who flock to see the brave (or perhaps foolish) people who run with bulls through the streets of the town's old quarter. The Encierro began as a way to get bulls from outside the city to the bullfighting ring inside; the tradition has grown over the years, attracting as many as 6,000 runners a day.

HOLIDATA

DATE: JULY 6 TO 14

LOCATION: PAMPLONA, SPAIN

FIRST OBSERVED: CIRCA 14TH CENTURY

SIGHTS: PEOPLE RUNNING FROM BULLS

SOUNDS: SNORTING BULLS, BOOMING ROCKETS

ON YOUR MARKS!

Every morning, the runners, who must be over 18, gather and chant three traditional prayers for protection. At eight o'clock, two rockets launch, six bulls charge out of their corral, and the runners take off. The full distance to the ring is roughly 900 yards (825 meters), but most runners do not make it the whole way. They must hop out of the way when the bulls get too close. When the bulls reach the bullring, a third rocket is launched. The fourth rocket lets everyone know that the bulls are safely in the corral and the running of the bulls has ended for the day.

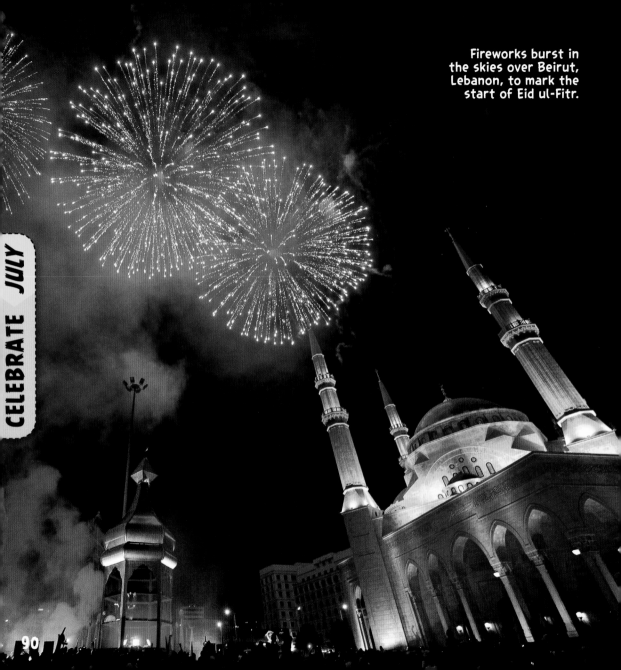

Fireworks burst in the skies over Beirut, Lebanon, to mark the start of Eid ul-Fitr.

EID UL-FITR

As one of the most sacred times in Islam comes to a close, one of the happiest is started. During the ninth lunar month of the Muslim calendar, called Ramadan, Muslims fast between sunrise and sunset. They use this time for spiritual reflection and self-improvement. When Ramadan ends, Muslims celebrate Eid ul-Fitr, which means "the festival of breaking the fast." Eid, as the celebration is commonly known, celebrates feasting and generosity. It is also a time to give to the poor while celebrating life's blessings with family and friends.

BREAKING THE FAST

The first day of Eid ul-Fitr is on Shawwal, the month that follows Ramadan. (Although Eid ul-Fitr is always on the same day of the lunar Islamic calendar, the date on the solar Gregorian calendar changes every year.) On that morning, people get up before dawn, bathe, and then put on their nicest clothes. Then they go to the mosque for prayers and return home for a delicious breakfast.

Over the course of the festival, which may last as long as three days in some countries, Muslims will visit friends and family, exchange gifts, and give food to the poor. Wonderful meals are prepared and shared; different regions have different specialties. In India, a sweet dessert made of noodles is popular, while small cookies made of semolina, dates, and pistachios are the treat of choice in Jordan.

HOLIDATA

DATE: THE FIRST DAY OF THE TENTH MONTH OF THE ISLAMIC CALENDAR

LOCATION: WORLDWIDE

ALSO CALLED: THE SUGAR FEAST, THE SWEET FESTIVAL

TRADITIONS: DONATING TO THE POOR, VISITING FAMILY AND FRIENDS, EXCHANGING GIFTS

GREETINGS: "EID MUBARAK" (BLESSED EID)

A sweet celebration!

THE WORLD CUP

Some call it football, others call it soccer. Call it what you want because the sport's popularity is undeniable. Soccer is the most loved sport in the world. And it's never more obvious than during the World Cup, a tournament where the world's best national teams compete for top honors. The Fédération Internationale de Football Association (FIFA), organizes World Cup Championships for both men's and women's teams. The men's tournaments have been held since 1930 (only stopping during World War II), and the women's since 1991. Teams must play a series of qualifying games to make it into the World Cup finals—only 24 men's teams make it, and just 16 of the women's. The international competition is fierce, but the goal is the same: to bring home the golden trophy.

FOOTBALL FRENZY

FIFA holds the World Cup every four years in a different country, and millions flock to see the games in person. Fans dress in their country's colors and often paint their faces. They hold signs, sing songs, and wave flags to cheer on their favorite teams and players. For those who cannot make it to the games in person, the World Cup is broadcast just about everywhere in the world, including Antarctica. And billions of people watch at home. In 2010, more than 3.2 billion people tuned in to watch the men's World Cup—almost half the world's population!

HOLIDATA

DATE: JULY, EVERY FOUR YEARS

LOCATION: COUNTRIES WORLDWIDE

FIRST PLAYED: 1930 (MEN'S), 1991 (WOMEN'S)

SIGHTS: SOCCER BALLS, STADIA PACKED WITH FANS

SOUNDS: "GOOAAAALLL!"

FESTIVE FACT

WITH FIVE WINS, BRAZIL HAS THE MOST MEN'S WORLD CUP WINS.

Two players from Thailand and Saudi Arabia battle it out for a chance to advance to the World Cup finals.

CELEBRATE AUGUST

Nicknamed the Bird's Nest, the National Stadium was built for the 2008 Summer Olympics hosted by Beijing, China.

THE SUMMER OLYMPICS

Every four years, the Summer Olympics roll around. One lucky city gets to host the games, and spectators come to see the world's top athletes compete for the coveted prize: an Olympic gold medal. From classic sports like swimming and track and field to recent additions like beach volleyball and handball, the action is riveting, and the victories are golden.

GOING FOR GOLD

The ancient Olympic games were held 3,000 years ago to honor the god Zeus—the first written records date to 776 B.C. when a cook named Coroebus won a footrace called the *stade* (the origin of the word "stadium"). The games fell out of favor during the Roman Empire, and weren't revived until 12 centuries later. The first modern Olympic Games was held in 1896 in Athens, Greece. More than 240 athletes from 14 countries came to compete in 9 different sports, including the marathon, fencing, and wrestling. The games have grown since then: When the Olympics returned to Athens in 2004, nearly 11,000 athletes from a record 201 countries competed for the gold in 28 thrilling summer sports.

HOLIDATA

DATE: HELD EVERY FOUR YEARS IN AUGUST

LOCATION: WORLDWIDE

FIRST OBSERVED: 1896

SIGHTS: WINNING MEDALS, THRILLING COMPETITION

SOUNDS: NATIONAL ANTHEMS, CHEERING FANS

FESTIVE FACT

TUG-OF-WAR WAS ONCE AN OLYMPIC SPORT.

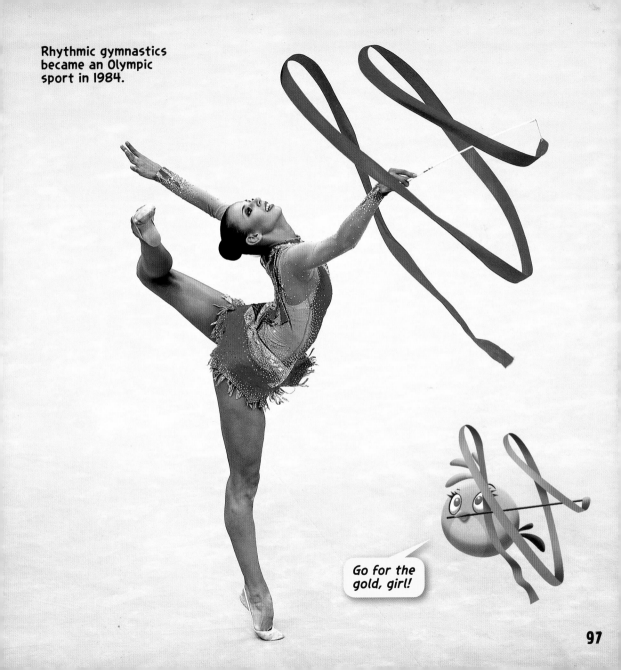

Rhythmic gymnastics became an Olympic sport in 1984.

Go for the gold, girl!

A vibrantly colored parade float lights up the night during the Aomori Nebuta Festival.

AOMORI NEBUTA FESTIVAL

Every summer in the Japanese city of Aomori, giant warriors, spirits, and demons walk the streets for seven days, all as part of the Aomori Nebuta Festival held every year to celebrate the harvest. "Nebuta" is a Japanese word meaning "parade float," and the colorful ones in this festival are made of wood, covered with Japanese paper, decorated, and then brightly lit by thousands of lights inside. The floats are impressive—vibrantly painted and standing as tall as 16 feet (5 meters) high. They take about a year to construct before they are ready to be paraded through the city streets.

EVERYBODY DANCE!

Over three million people take part every year. Hundreds of dancers called *haneto* move to the rhythm of large taiko drums and the music of bamboo flutes. They wear traditional costumes (a summer kimono, a hanagasa hat, and a tasuki sash) and chant "Rasse, Rasse" as they invite people in the crowd to dance with them. Each night the floats are wheeled into the streets (except on the last day when the procession is in the afternoon) and the fun starts all over again.

NEBUTA KNOWLEDGE

JAPANESE WORD	FUE	HANETO	RASSE, RASSE	TAIKO
MEANING	BAMBOO FLUTE PLAYING PARADE MUSIC MELODIES	NEBUTA DANCERS WEARING THE TRADITIONAL COSTUME	THE SHOUT ENDLESSLY CHANTED BY THE HANETO DANCERS	THE DRUMS FOR THE PARADE MUSIC

Forty thousand to fifty thousand people show up to throw tomatoes at one another during La Tomatina.

CELEBRATE AUGUST

LA TOMATINA

Try

Hold on to your tomatoes because you'll need them for ammunition at La Tomatina, the world's biggest food fight held every summer in Spain! The town of Bunol hosts this weeklong festival, which starts on the last Wednesday of August every year. There's music, parades, dancing, fireworks, and a paella-cooking contest. But the highlight is when 40,000 to 50,000 people show up to pelt each other with more than 220,000 pounds (100 metric tons) of tomatoes.

to

TONS OF TOMATO TOSSING

The tomatoes for the event sit in a pile in the center of town, the Plaza del Pueblo, but before the fight can begin, participants must first climb a large greased pole and retrieve a ham that has been placed on top. Once the ham is down, the food fight can start. For safety's sake, the tomatoes have to be squished before they can be thrown. The festival's organizers also recommend that participants where safety goggles and gloves. To signal the start, a large cannon fires and then it's anyone's game. People are free to throw as many tomatoes as they can for the next one to two hours. Another cannon will fire to signal the end of the food fight, and fire trucks are brought in to clean up the big, red mushy mess.

ketchup!

HOLIDATA

DATE: THE LAST WEDNESDAY OF AUGUST

LOCATION: BUNOL, SPAIN

FIRST FOUGHT: 1944 OR 1945

SIGHTS: TOMATO-COVERED PEOPLE

SOUNDS: SPLATTING TOMATOES AND CANNON BLASTS

HENLEY-ON-TODD REGATA

To have a boat race, it seems that water would be absolutely necessary. But it turns out that it's not. Just ask the residents of Alice Springs, Australia, who host a boat race on the Todd River's dry riverbed each August. It all started in 1962, when Alice Springs resident Reg Smith suggested recreating the Henley-on-Thames race between Cambridge and Oxford Universities. The fact that Alice Springs isn't located near any large bodies of water didn't bother anyone, and the local Rotary Club organized the event.

WATER, WATER NOWHERE

The Henley-on-Todd Regatta is a fun-filled festival where bottomless boats and costumed captains compete against each other in a variety of events. There's the "Head of the River" in which eight people crew a bottomless boat to race to a buoy and back. In the "Bath Tub Derby," teams carry a lady in a bathtub to a buoy, pour a bucket of water in the tub, and then race back to the finish line. In the "Battle Boat Spectacular," three motorized boats exchange fire with flour bombs and water cannons.

HOLIDATA

DATE: LATE AUGUST

LOCATION: ALICE SPRINGS, AUSTRALIA

FIRST OBSERVED: 1962

SIGHTS: BOTTOMLESS BOATS, BATHTUBS, SAND SKIS

SOUNDS: CHEERING CROWDS, CRUNCHING SAND

FESTIVE FACT
HENLEY-ON-TODD HAS BEEN CANCELED ONE TIME—DUE TO FLOODING IN 1993.

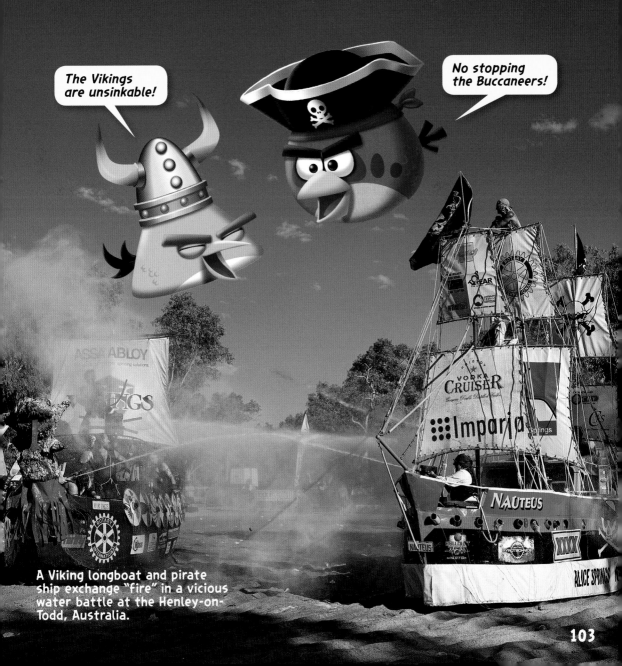

A Viking longboat and pirate ship exchange "fire" in a vicious water battle at the Henley-on-Todd, Australia.

103

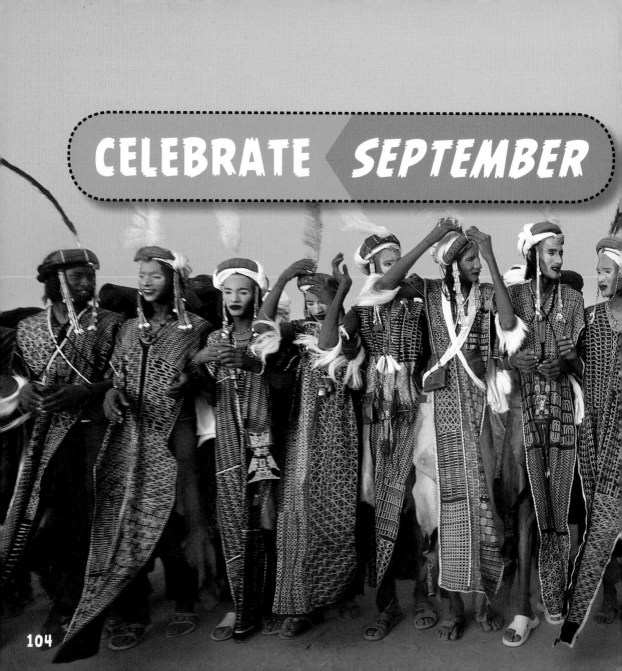

CELEBRATE SEPTEMBER

In Niger, the Wodaabe men get all dressed up for the Gerewol festival.

LABOR DAY

The first Monday in September is when the United States honors its workers with a day off. It was created in the late 1800s, after the industrial revolution swept through the United States. New factories and plants sprang up across the nation, and the people who toiled in them rallied together to protect their rights as well as celebrate their contributions. On September 5, 1882, workers in New York City held the first Labor Day parade in which they marched from City Hall to Union Square. After that, the idea of a workers' holiday spread to other cities, and many states began to recognize it. Twelve years later in 1894, Congress made Labor Day a national holiday, which has been celebrated ever since.

A DAY OFF FROM WORK

Today, Labor Day honors everyone who works for a living. Many cities and towns hold parades and fireworks displays, while families often celebrate with parties and backyard cookouts. For many, the day has also come to symbolize the last day of summer because many local schools have their first day of classes in the days following Labor Day.

HOLIDATA

DATE: THE FIRST MONDAY IN SEPTEMBER

LOCATION: THE UNITED STATES

FIRST OBSERVED: 1882

SIGHTS: BACKYARD CELEBRATIONS

SOUNDS: PARADE MARCHING

FESTIVE FACT
OREGON, NEW YORK, NEW JERSEY, AND COLORADO WERE AMONG THE FIRST STATES TO MAKE LABOR DAY A HOLIDAY.

Big wheel-riding Shriners take part in the Labor Day Parade in Janesville, Wisconsin.

During Rosh Hashanah, some Jewish people symbolically cast off last year's sins by tossing pieces of food into a moving body of water to start the New Year with a clean slate.

L'Shana Tovah!

ROSH HASHANAH

Loud parties and late nights aren't a part of celebrations of the Jewish New Year, which is called Rosh Hashanah (it means "Head of the Year" in Hebrew). Instead, this holiday, which falls on the first day of the seventh Hebrew month (in September or October), is a time for contemplation. Rosh Hashanah is the beginning of the Days of Awe, a ten-day period that ends on Yom Kippur, the Day of Atonement. These two holidays are among the holiest Jewish holidays.

HOLIDATA

DATE: THE FIRST DAY OF THE SEVENTH HEBREW MONTH (SEPTEMBER OR OCTOBER)

LOCATION: WORLDWIDE

ALSO KNOWN AS: YOM TERUAH ("THE DAY OF THE SOUNDING OF THE SHOFAR" IN HEBREW)

TRADITIONS: BLOWING THE SHOFAR, EATING SWEET FOODS

GREETINGS: "L'SHANA TOVAH" ("FOR A GOOD YEAR" IN HEBREW)

SOUND OF THE SHOFAR

On Rosh Hashanah, many Jewish families go to pray at a synagogue, a Jewish house of worship. They sing songs and read from a special prayer book called the *machzor*. As part of the services, an ancient musical instrument called a shofar is played. Traditionally made of a ram's horn, the shofar is blown in a specific sequence of notes and phrases to start the holiday. After prayers are over, people gather together for a festive meal that includes sweet foods, like apples dipped in honey or challah baked with raisins, to "sweeten" the coming year.

FESTIVE FACT

THE BASIC DESIGN OF THE SHOFAR HAS NOT CHANGED IN 5,000 YEARS.

A floating dragon lantern lights up the night to celebrate the Mid-Autumn Festival in Beijing, China.

MID-AUTUMN MOON FESTIVAL

As fall grows nearer, the people in China get ready for the Mid-Autumn Moon Festival. On the 15th day of the 8th lunar month (usually in mid to late September), the moon is big, bright, and appears perfectly round. The holiday has been celebrated for centuries in China, and is one of the most important holidays. Traditions vary by region—for instance, in Hong Kong, dragon dances are popular. Often, people celebrate with their families, gather to appreciate the full moon, and eat tasty mooncakes.

MOONCAKES

Eating mooncakes is the most common tradition during the festival across China. Traditionally, mooncakes are round pastries stamped with images of Chang'e, the moon goddess. They are stuffed with different foods that vary by region. Common fillings are red bean paste, sesame paste, lotus seed paste, egg yolks, and sugar. The mooncake's round shape mimics the full moon and symbolizes reunion with family. In the past, people treated this food as a sacrificial offering to the moon, while today it has become a gift to friends and family to wish them good luck and abundance.

HOLIDATA

DATE: THE 15TH DAY OF THE 8TH CHINESE MONTH (MID- TO LATE SEPTEMBER)

LOCATION: CHINA

EARLY OBSERVANCES: 2,000 YEARS AGO

ALSO KNOWN AS: ZHONG QIU JIE

TRADITIONS: EATING MOON-CAKES, MOON GAZING, FAMILY REUNIONS

Are they making eyes at me?

GEREWOL FESTIVAL

Many of the world's most famous beauty pageants feature women, but during the Gerewol festival, men compete to see who's the fairest of them all. Gerewol is a celebration held by the traditionally nomadic Wodaabe people of Niger. As part of the fun, men compete for the attention and affection of the judges, the Wodaabe women. The courtship ritual occurs each year around September (if the rainy season has been good), before the Wodaabe move their cattle to their dry-season pastures.

HEY, GOOD LOOKIN'

To compete, the young men in the tribe try to look their best. They spend hours painting their faces with rare (some say magical) pigments. An ideal man has a high forehead, wide eyes, a long nose, and straight white teeth, and their makeup helps these features stand out. The men then dress in tunics that hang to their ankles and turbans with ostrich feathers on their heads (to help them appear taller). After dressing, they dance in an event called the Yaake, which can last for hours, until the judges are satisfied and pick the three most beautiful men.

WHAT WODAABE WOMEN WANT				
BEAUTY TRAIT	HEIGHT	EYES	HAIR	TALENT
WHAT THEY'RE LOOKING FOR	THE TALLER, THE BETTER, INCLUDING WEARING OSTRICH PLUMES TO ADD HEIGHT	WIDE EYES ENHANCED WITH BLACK EYELINER	LONG BRAIDS DECORATED WITH COWRIE SHELLS TO SYMBOLIZE FERTILITY AND WEALTH	GOOD DANCING, AND JEWELRY THAT JANGLES IN TIME WITH THE MUSIC

The elaborate makeup of the Wodaabe men enhances the eyes, making them appear stronger and more alluring.

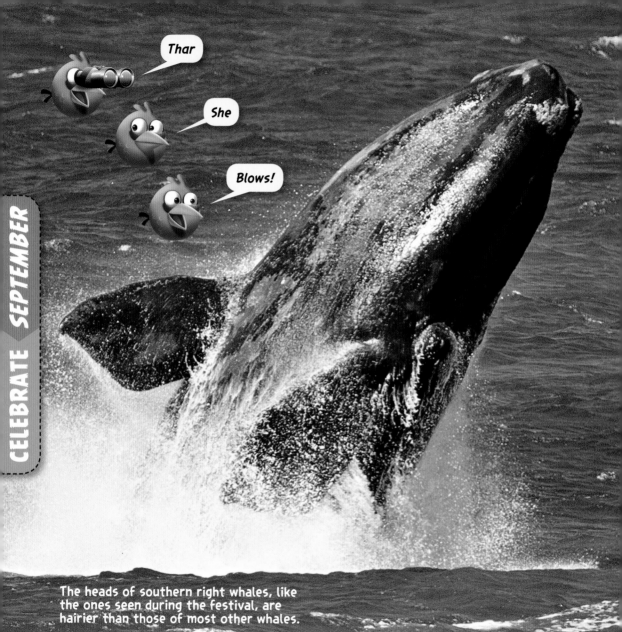

The heads of southern right whales, like the ones seen during the festival, are hairier than those of most other whales.

HERMANUS WHALE FESTIVAL

Every September off the coast of South Africa, when spring is just around the corner, the southern right whales come back to the waters of Walker Bay. The people of Hermanus, the town situated along the coastline, hold a big festival to celebrate the whales' return each year. More than 100,000 spectators come to line the cliffs around the water and see the whales swim during the day. At the fairgrounds, there are concerts, comedy shows, shopping, and African music all day long and into the night. The festival lasts for four days, but the whales may stay in the bay through November.

WHERE THE WHALES ARE

When the festival is in full swing, the Hermanus whale crier lets spectators know where to see the whales. He carries a kelp horn and blows it each day to tell people the best viewing location. Each place has a certain "code" consisting of different sequences of short and long blasts. The Crier wears a sandwich board that lists each location, the rhythm of its code, and lists how many whales have been spotted so far. Once people hear the Crier blow the code, locals and tourists can position themselves along the best viewing spots along the bay.

HOLIDATA

DATE: LATE SEPTEMBER

LOCATION: HERMANUS, SOUTH AFRICA

FIRST CELEBRATED: 1991

SIGHTS: SOUTHERN RIGHT WHALES SWIMMING

SOUNDS: THE WHALE CRIER'S KELP HORN

CELEBRATE OCTOBER

An Indian mother and daughter celebrate Diwali, the Indian festival of lights.

OKTOBERFEST

Here's a recipe for the world's biggest fair: Take more than six million people, add about one and a half million gallons (six million liters) of beer, and mix for 16 days. The result is Oktoberfest, a perfect blend of Bavarian culture, tons of food, and loads of fun for everyone. The festival begins each year in late September and ends on the first Sunday in October. Fourteen big tents are erected on "die Wiesn," the traditional fairgrounds, where they dispense beers exclusively from Munich's six select breweries, each one with its own unique history and flavor. Alongside the tents is a fairground with carnival rides and other attractions such as crossbow competitions, a flea circus, marching bands, and costume parades.

Sprechen sie Angry Birds?

WEDDING PARTY

Oktoberfest got its start as the ultimate wedding reception. In 1810, the Bavarian Crown Prince Louis married Princess Therese von Sachsen-Hildburghausen. To celebrate the wedding, the royal families held a big party on the fields in front of the city gates and invited all the people of Munich. The fields were named Theresienwiese (Therese's Fields) in honor of the princess, which the locals shortened to just "Wies'n." The festivities were repeated every year on the anniversary and blossomed into the annual Oktoberfest. Around the world, many other cities now have their own Oktoberfests modeled after the original.

HOLIDATA

DATE: LATE SEPTEMBER THROUGH THE FIRST SUNDAY IN OCTOBER

LOCATION: MUNICH, GERMANY

FIRST OBSERVED: 1810

SIGHTS: BAVARIAN BEER, LEDERHOSEN

SOUNDS: TRADITIONAL BAVARIAN MUSIC, BEER MUGS CLINKING

118

Dressing up in Bavarian costumes is one fun Oktoberfest tradition.

New York City's Hispanic Columbus Day Parade celebrates the spirit of discovery and the contributions of Hispanic people.

COLUMBUS DAY

When Italian explorer Christopher Columbus landed on San Salvador in the Bahamas, it was the culmination of a mission, but not the one he originally had in mind. Sponsored by the Spanish king and queen, Columbus sailed three ships—the *Niña*, the *Pinta*, and the *Santa Maria*—across the Atlantic Ocean in 1492, searching for a faster trade route to the Indies. What he found were the islands, the peoples, and the civilizations of the Caribbean and the Americas. The day of this arrival, October 12, has become a holiday in many countries in the Americas, albeit one with a complicated legacy.

A COMPLICATED LEGACY

In the United States, Columbus Day became a holiday in 1937 that honors the bravery of Columbus and his spirit of exploration. The holiday has also grown into a celebration of Italian-American heritage—one of the biggest can be found in New York City, where the annual Columbus Day Parade features marching bands, floats, and up to a million spectators every year. Many native peoples see a different side to Columbus's history and interpret it as the beginning of colonization. Venezuela, Nicaragua, and Argentina have renamed the holiday to recognize the experience of indigenous peoples. In other Latin American countries, October 12 is a celebration of the roots of Hispanic culture and called Dia de la Raza (Day of the Race).

HOLIDATA

DATE: OCTOBER 12

LOCATION: NORTH AND SOUTH AMERICA

FIRST OBSERVED: 20TH CENTURY

SIGHTS: PARADES

SOUNDS: MARCHING BANDS

DIWALI

Diwali is the magnificent Hindu festival of lights. Originally a harvest festival to thank the gods for a bountiful harvest, the holiday is a celebration of light and goodness. The name of the holiday comes from the Hindi word *deepavali,* which means "row of lights." Whether modern strings of electric lights or traditional glittering clay lamps, the main Diwali decoration is myriad twinkling lights that cover homes and other buildings. Diwali is a glittering celebration that happens every October or November according to the Hindu lunar calendar.

A dazzling display!

LIGHT THE LIGHTS!

Diwali lasts for five days, and families celebrate in many ways. They gather together, exchange gifts, eat feasts, and enjoy huge fireworks displays. During Diwali, many honor the Hindu goddess Lakshmi, who governs wealth and prosperity, by opening their doors and windows to welcome her into their home. Other Indians honor the Hindu god Rama, who along with his wife Sita were banished from their homeland for 14 years. Lamps are lit to guide them on their return from exile.

THE FIVE DAYS OF DIWALI	
THE DAY	THE ACTIVITY
DAY ONE	CLEAN THE HOUSE AND PURCHASE NEW THINGS FOR THE KITCHEN
DAY TWO	DECORATE THE HOUSE WITH CLAY LAMPS AND RANGOLI, BEAUTIFUL DESIGN PATTERNS MADE OF COLORED SAND
DAY THREE	LIGHT THE LIGHTS AND GATHER WITH FAMILY TO PRAY, FEAST, AND WATCH FIREWORKS
DAY FOUR	VISIT FRIENDS AND EXCHANGE GIFTS
DAY FIVE	VISIT YOUR BROTHER OR SISTER AND THEIR FAMILY FOR ONE LAST BIG MEAL

Lighting small lamps, called *diyas*, is a twinkling Diwali tradition.

123

Carving
pumpkins into
jack-o'-lanterns
at Halloween
began in Ireland.

HALLOWEEN

On the last dark night of October, fear and fun unite for Halloween, a haunted holiday whose origins go back thousands of years to the Celts. These ancient people lived in Britain and France and believed that ghosts could return to Earth on October 31, the day before their new year. To keep them away, the Celts lit huge bonfires and dressed up in costumes. They called this festival Samhain, which means "end of summer." November 1 was the beginning of the new year as well as winter, a time associated with darkness and death. When Christianity came to the Celts centuries later, these traditions evolved. November 1 became Allhallows Day (called All Saints' Day today), a time to honor saints and martyrs. October 31 then became All Hallows' E'en, which was later morphed into Halloween.

TRICKS AND TREATS

European immigrants, particularly those from Britain, brought Halloween to the United States in the 18th and 19th centuries. Every October 31, children dress up in costumes—from specters to superheroes—and go trick-or-treating for candy in their neighborhoods. The holiday has flourished and is now one of the most popular holidays of all—Americans have spent almost $8 billion on costumes, candy, and decorations. That's a lot of treats!

HOLIDATA

DATE: OCTOBER 31

LOCATION: UNITED STATES

FIRST OBSERVED: 2,000 YEARS AGO

TRADITIONS: WEARING COSTUMES, PLAYING PRANKS, GOING TRICK-OR-TREATING

GREETINGS: "HAPPY HALLOWEEN!"

FESTIVE FACT
EACH YEAR AMERICANS SPEND ROUGHLY $300 MILLION ON HALLOWEEN COSTUMES—FOR THEIR PETS.

CELEBRATE NOVEMBER

The Macy's Thanksgiving Day Parade typically features 11 marching bands, 27 floats, 44 giant balloons, and 800 clowns.

DIA DE LOS MUERTOS

In most horror movies, the return of the dead is portrayed as scary, but that's not so in Mexico and Latin America. On the Dia de los Muertos, or "Day of the Dead," visits from dead loved ones are welcomed and celebrated with joy. Blending ancient Mesoamerican rituals with religious beliefs from the Spanish conquistadores, Dia de los Muertos is celebrated on November 1 and 2, All Saints' Day and All Souls' Day respectively, and reflects the belief that death is just a part of life and not to be feared.

FIESTA FOR PHANTOMS

During Dia de los Muertos, the dead are honored with music, dancing, and food—all the activities they enjoyed in life. To prepare for their "visitors," families build altars for their deceased loved ones. Candles are lit, incense is burned, and the altars are decorated with colorful punched paper, marigolds, photographs, the deceased's favorite things to eat and drink. They even set out a washbasin and towel so the spirit can wash up before the party.

HOLIDATA

DATE: NOVEMBER 1 AND 2

LOCATION: MEXICO, LATIN AMERICA

ORIGINATED IN: CIRCA 14TH TO 16TH CENTURIES

SIGHTS: DECORATED ALTARS, SUGAR CANDY SKULLS, MARIGOLDS

SOUNDS: CHEERFUL MUSIC

FESTIVE FACT
DIA DE LOS MUERTOS CANDY TREATS ARE CALAVERAS DE AZÚCAR, SKULLS MADE OUT OF SUGAR.

Popular decorations for Dia de Los Muertos, *calacas* are joyful skeleton figurines that represent a happy afterlife.

Ready for launch!

A team prepares to fire its pumpkin into the skies over Delaware at the Punkin Chunkin festival.

PUNKIN CHUNKIN

Look out below! Flying pumpkins may be headed your way if you're in Bridgeville, Delaware, in early November. That's the time for the annual World Championship Punkin Chunkin, a three-day festival where teams compete to see just how far they can toss a pumpkin. It all started in 1986, when four friends read an article about pumpkin-based physics experiments to teach students about energy and mass. They began to design their own experiments, and it grew into a huge event drawing tens of thousands of people each year. In addition to tossing pumpkins, the festivities feature lots of live music, the Miss Punkin Chunkin Pageant, and a cooking contest.

PUNKIN PHYSICS

Teams of backyard engineers compete in several different age classes and divisions, including air cannon, catapult, human power, trebuchet, theatrical (decided by popular vote), and torsion. The design of each launcher determines the division. During the competition, teams launch pumpkins into the air to see whose gourd flies the farthest. So far, the most successful machines have relied on compressed air. The current record holder, team Young Glory III shot a pumpkin 4,438 feet (1,353 meters), just 800 feet (244 meters) shy of a mile.

PUNKIN CHUNKIN RULES

1. PUMPKINS MUST WEIGH BETWEEN EIGHT AND TEN POUNDS.
2. ALL PUMPKINS FIRED MUST REMAIN INTACT UNTIL THEY HIT THE GROUND.
3. NO PART OF THE MACHINE SHALL CROSS THE FIRING LINE.
4. NO WADDING CAN BE USED IN THE MACHINES.
5. NO EXPLOSIVES OR ELECTRICITY CAN BE USED.

More than 100 teams compete every year at Big Pig Jig, Georgia's oldest barbecue festival.

EAT

MORE VEGGIES!

BIG PIG JIG

Claiming that you can barbecue the best pork are fighting words in the southern United States, ones that led to the creation of one of the nation's biggest barbecue festivals. The Big Pig Jig all started back in 1982 in Georgia, with a wager among friends who all thought they could cook the best pig. They staged their contest at a popular Georgia fair, where 20 teams each cooked a whole pig. The crowds at the carnival loved the contest, and a new barbecue tradition was born.

LET THEM EAT PORK!

Today, the Big Pig Jig is held every year in early November in Vienna, Georgia. Contestants can compete for the Grand Championship in three different categories: Whole Hog, Pork Shoulder, and Pork Ribs. For the purposes of the competition, barbecue is defined as "pork meat (fresh or frozen and uncured) prepared only on a wood and/or charcoal fire, basted or not as the cook sees fit, with any nonpoisonous substances and sauces as the cook believes necessary." More than 100 teams now compete, and 200 people judge the event. In addition to the cooking contests, there is a Big Pig Jig Parade, appearances by the winner of the Miss Big Pig Jig beauty pageant, live music, and a 5k run (so you can work off that pork!).

HOLIDATA

DATE: EARLY NOVEMBER

LOCATION: VIENNA, GEORGIA

FIRST OBSERVED: 1982

SIGHTS: TASTY BARBECUE, MISS BIG PIG JIG

SOUNDS: SIZZLING PORK

Bonfire societies dress up and parade through the streets of Lewes, England, on Guy Fawkes Day.

GUY FAWKES DAY

Guy Fawkes Day is celebrated every November 5 in Britain with big fireworks displays and bonfires. Before the holiday, children often make dummies of Guy Fawkes out of old clothes and newspapers. The "Guys" are carried around town, and children ask passersby for a "Penny for the Guy." They keep the money and use it to buy fireworks to set off on November 5. But who was the real Guy Fawkes, and what does he have to do with explosions? Well, quite a bit.

AN EXPLOSIVE SITUATION

Fawkes was a mercenary who became part of a conspiracy to blow up the Houses of Parliament on November 5, 1605. The Gunpowder Plot, as it came to be known, has unclear origins and motivations—the official version is that it was a Catholic plan to overthrow the Protestant king. Five conspirators, including Fawkes, planned the explosion for State Opening Day, when the king and the members of Parliament would all be present. The plot was foiled when a lord was tipped off; he ordered a search, and Fawkes and 36 barrels of gunpowder were discovered. He was arrested and executed a few months later. Parliament decreed the day of the botched plot a holiday and named it after Fawkes to commemorate the execution of a traitor.

HOLIDATA

DATE: NOVEMBER 5

LOCATION: ENGLAND

FIRST OBSERVED: 1606

SIGHTS: BONFIRES, EFFIGIES OF GUY FAWKES

SOUNDS: BOOMING FIREWORKS

THANKSGIVING

Please

In the United States, Thanksgiving rolls around on the fourth Thursday of November. On this holiday, people gather together to enjoy each other's company, watch some football, and feast on a great big meal. Thanksgiving's history dates back to the 1620s, when a harsh Massachusetts winter took the lives of half the English Pilgrims who had settled there. The following spring, an Indian named Squanto taught the survivors to plant corn and other crops. The next fall, harvest was a great success, and the Pilgrims held a thanksgiving celebration. They invited the local Indians, to thank them for their help. After that, Thanksgiving became an American tradition, and Abraham Lincoln made it a national holiday in 1863.

HOLIDATA

DATE: THE FOURTH THURSDAY IN NOVEMBER

LOCATION: UNITED STATES

FIRST OBSERVED: 1863 (UNITED STATES)

TRADITIONS: BEING GRATEFUL, COOKING, OVEREATING, WATCHING PARADES

GREETINGS: "HAPPY THANKSGIVING!"

GOBBLE! GOBBLE!

Even though most Americans no longer celebrate the harvest of their own food, cooking and sharing Thanksgiving Day dinner remains a focus of the holiday. Turkey was not the main attraction of the first Thanksgiving, but more than 90 percent of Americans today eat turkey on Thanksgiving. Other traditional foods include stuffing, mashed potatoes, gravy, cranberry sauce, pumpkin pie, and apple pie. The first Thanksgiving was heavier on the meat; it's reported that turkey, venison, duck, goose, lobsters, clams, corn, vegetables, and dried berries were all on the menu in 1621.

the potatoes!

Pass

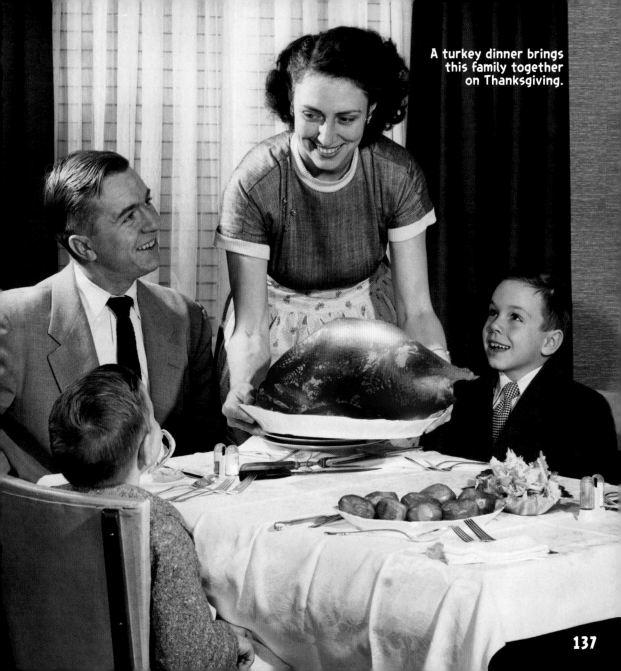

A turkey dinner brings this family together on Thanksgiving.

CELEBRATE DECEMBER

Many people love to deck their halls with lots of holiday lights.

Eight

HANUKKAH

Happy

For eight happy days and nights in December, Jewish people around the world celebrate Hanukkah. The festival commemorates a military victory and a rededication of the temple in Jerusalem more than 2,000 years ago. In the second century B.C., the king of Syria took over Judea (modern-day Israel), outlawed the Jewish religion, and seized the Jewish temple. For three years, the Maccabee family led a revolt before they won back their land and the temple, which they rededicated to God ("Hanukkah" means "dedication" in Hebrew). When they went to relight the temple lights, they only found oil enough for one day. But then, a miracle occurred. According to the story, the lamps were lit, and the oil lasted for eight days, which is why Hanukkah is also known as the Festival of Lights.

A CANDLELIT CELEBRATION

Every night of Hanukkah, Jews light candles in a menorah, a special candleholder with spaces for nine candles—one for each night plus a "helper" candle called the shammes that lights the others. On each night, a candle is added to the menorah and lit after sundown. During the ritual, families say special blessings and prayers. Families often cook and eat potato pancakes, called latkes, which have been cooked in oil. Other customs include playing with a four-sided top called a dreidel and exchanging gifts.

HOLIDATA

DATE: THE 25TH DAY OF THE 9TH HEBREW MONTH (LATE NOVEMBER TO MID-DECEMBER)

LOCATION: WORLDWIDE

FIRST OBSERVED: 2 B.C.

TRADITIONS: LIGHTING THE MENORAH, SPINNING THE DREIDEL

GREETINGS: "HAPPY HANUKKAH!"

Nights!

A giant menorah is lit in Clearwater Beach, Florida, to celebrate Hanukkah.

Mmmmm! Tasty little dumplings!

DONGZHI FESTIVAL

The Dongzhi Festival is a one-day celebration of the winter solstice in China and other Asian countries. An ancient and important festival, it has a long history that stretches back to the Han dynasty, which lasted from 200 B.C. to A.D. 200. In its early incarnation, the winter solstice marked the end of the harvest and the return home of farmers, who had often been away in the fields for many months. The festival evolved into a family celebration of the end of the shortest, darkest days of the year, gratitude for the harvest, and family reunions.

ON THE MENU

Gathering with family and feasting together remain the cornerstones of this holiday. Different regions of China have different foods associated with the Dongzhi feast. In northern China, people eat dumplings stuffed with meat. In southern China as well as Taiwan and Hong Kong, the traditional food is called tang yuan, balls of glutinous rice that are dyed bright colors. They may be stuffed with sweet sesame, peanut, or red bean paste and served in soup. Tang yuan symbolizes family unity and harmony in keeping with the theme of the Dongzhi Festival.

HOLIDATA

DATE: DECEMBER 22

LOCATION: CHINA, TAIWAN, HONG KONG

FIRST OBSERVED: CIRCA 200 B.C.

TRADITIONS: FAMILY REUNIONS, EATING DUMPLINGS

GREETINGS: "DONG ZHI KUAI LE!" ("HAPPY WINTER SOLSTICE!")

Chinese students from China's Shandong Province proudly display the dumplings they made for Dongzhi.

Stella

Red

Bomb

Matilda

Chuck

Terence

Blue Blue Blue

Many American children leave cookies and milk by the fireplace for Santa Claus.

CHRISTMAS

When December 25 rolls around, its time to break out the jingle bells, hang up a stocking, and have a merry Christmas. Christians all over the world celebrate this joyous holiday as the anniversary of the birth of Jesus more than two thousand years ago. The exact date of Jesus' birth has not been established (the Bible does not identify it), but in A.D. 350, the church began celebrating it in December with services, feasts, and masses.

HO HO HO!

Christmas is a holiday filled with tons of jolly traditions—from singing Christmas carols to baking gingerbread cookies to reading "A Visit From Saint Nicholas." People festively decorate their homes with strings of twinkling lights, nativity scenes, and fragrant Christmas trees. Many attend church services and visit family and friends to exchange gifts and share big, delicious meals. And children everywhere must contain their excitement as they wait for Santa Claus to arrive with presents (for everyone who's been nice!).

> Have you been naughty or nice?

HOLIDATA

DATE: DECEMBER 25

LOCATION: WORLDWIDE

FIRST OBSERVED: A.D. 350

TRADITIONS: SINGING CAROLS, DECORATING TREES, EXCHANGING GIFTS, SENDING CARDS

GREETINGS: "MERRY CHRISTMAS!"

FESTIVE FACT
FOR 22 YEARS IN THE 1600S, CHRISTMAS WAS BANNED IN BOSTON, MASSACHUSETTS.

KWANZAA

Starting on December 26, many African-American families celebrate Kwanzaa, a weeklong festival that honors their heritage, traditions, and kinship. First celebrated in 1966, the holiday lasts for seven days, and on each one, families celebrate one of the Nguzo Saba, or seven principles.

Candles for Kwanzaa!

LIGHT A CANDLE

As part of the celebration, many families decorate their homes with seven important objects that have special names and meanings. A woven mat called a *mkeka* is laid on a table, symbolizing the foundations of history. Fruits and vegetables, called *mazao,* are placed on top, to represent the fruits of the harvest. *Muhindi* are dried ears of corn, and one representing each child is placed on the mkeka. The *Kikombe cha Umoja,* or unity cup, symbolizes unity. *Zawadi* are Kwanzaa gifts from parents to their children. And at the center is the *kinara,* a candleholder, and the *mishumaa saba,* seven candles of Kwanzaa. Every night of Kwanzaa, the family gathers around the kinara to light one candle and discuss one of the seven principles of Kwanzaa. On the last night, there is a big feast called a *karamu,* where loved ones gather to make music, tell stories, and celebrate together.

THE SEVEN PRINCIPLES OF KWANZAA	
SWAHILI WORD	ENGLISH TRANSLATION
I. UMOJA	UNITY
2. KUJICHAGULIA	SELF-DETERMINATION
3. UJIMA	COLLECTIVE WORK AND RESPONSIBILITY
4. UJAMAA	COOPERATIVE ECONOMICS
5. NIA	PURPOSE
6. KUUMBA	CREATIVITY
7. IMANI	FAITH

JUNKANOO

Strike up the band, put on a costume, and get ready for one of the Caribbean's most spectacular festivals! Every December 26, the streets of Nassau in the Bahamas are filled with vibrant colors, irresistible rhythms, joyful music, and exuberant dancing during the annual Junkanoo celebration. Junkanoo is a parade that begins in the early hours of the morning (typically 2 a.m.) and lasts until about 10 a.m. Dance troupes, musicians, and costumed performers "rush out" into the street to promenade and perform along the parade route in flamboyant costumes made of feathers, cardboard, spangles, and colorful crepe paper. At the end of the parade, judges give out prizes for the best dancing, best costume, and best overall presentation.

MYSTERIOUS ORIGINS

There are several different origin stories for Junkanoo, but many believe that the festival began during African enslavement in the 16th and 17th centuries in the Bahamas. The day after Christmas was a special holiday for slaves, who were allowed to leave plantations to visit their families. During these reunions, they celebrated with African music, dancing, and costumes. After slavery ended, the holiday remained, and descendants continued celebrating Junkanoo and turned it into a joyful cultural phenomenon.

Time to boogie!

HOLIDATA

DATE: DECEMBER 26, JANUARY 1, SUMMER

LOCATION: THE BAHAMAS

FIRST CELEBRATED: 16TH AND 17TH CENTURIES

SIGHTS: BRIGHTLY COLORED COSTUMES, DANCING

SOUNDS: BOOMING DRUMS, CHEERFUL MUSIC

148

Festively dressed Junkanoo dance troupes can have as many as 1,000 people in them.

Booming fireworks bring in the New Year over the boats in Sydney Harbor, Australia.

NEW YEAR'S EVE

In many countries around the world, December 31 is the last day of the year. It's time to look back and celebrate the past 12 months, and time to look ahead to the year to come. Although December 31 has only been New Year's Eve for about 400 years or so, civilizations have long celebrated the coming of the new year. The earliest known celebration dates back 4,000 years to ancient Babylon. The Romans were the first to place their new year in January in 46 B.C., and Europe began to follow suit in 1582.

A LUCKY HOLIDAY

New Year's Eve traditions bring in the new year with merriment and a little superstition. Many people go to parties, eat lucky foods, make lots of noise, and make resolutions for the coming year. In Spanish-speaking countries, eating 12 grapes, one for each month, will bring good luck. Pigs mean prosperity in Italian, Cuban, Austrian, and Portuguese culture, so pork is on many New Year's Eve menus. Getting together with friends is also a popular tradition: In the U.S., people gather outside in the cold in New York City to watch a giant, glittering ball drop at midnight in Times Square. Nothing like a celebration with shivering folks to warm you up and welcome the new year!

HOLIDATA

DATE: DECEMBER 31

LOCATION: GLOBAL

FIRST OBSERVED: 1582

TRADITIONS: EATING LUCKY FOODS, MAKING LOUD NOISES, MAKING RESOLUTIONS

GREETINGS: "HAPPY NEW YEAR!"

FESTIVE FACT
ONE LATIN AMERICAN TRADITION SAYS THAT WEARING YELLOW UNDERWEAR ON NEW YEAR'S EVE USHERS IN PROSPERITY.

Reasons for the Seasons:
Solstices and Equinoxes

Because the Earth's axis is tilted, different parts of the world receive more direct sunlight during different parts of the year.

On the days when the sun can be seen directly overhead in three specific places on the globe, the seasons change. The first is the equator, the imaginary line encircling the middle of the planet: When sunlight shines on it in March and then again in September, you have an equinox, either the first day of spring or fall. Solstices are the days when the sunlight reaches its farthest northern and southern points.

In June, sunlight reaches the northernmost point, a line called the Tropic of Cancer. In December, sunshine is farthest south, a line called the Tropic of Capricorn. Solstices mark the beginnings of the coldest and hottest seasons—which one depends on which part of the world you live in.

APPROXIMATE DATE	POSITION OF THE SUN	NORTHERN HEMISPHERE SEASON	SOUTHERN HEMISPHERE SEASON
MARCH 20-21	EQUATOR	SPRING	AUTUMN
JUNE 20-21	TROPIC OF CANCER	SUMMER	WINTER
SEPTEMBER 22-23	EQUATOR	AUTUMN	SPRING
DECEMBER 21-22	TROPIC OF CAPRICORN	WINTER	SUMMER

Birthstones and Birth Flowers

The 12 months of the year all have gems
and blossoms associated with them.

MONTH	BIRTHSTONE	BIRTH FLOWER
JANUARY	GARNET	CARNATION
FEBRUARY	AMETHYST	VIOLET
MARCH	AQUAMARINE	DAFFODIL
APRIL	DIAMOND	DAISY
MAY	EMERALD	LILY OF THE VALLEY
JUNE	PEARL	ROSE
JULY	RUBY	LARKSPUR
AUGUST	PERIDOT	GLADIOLA
SEPTEMBER	SAPPHIRE	ASTER
OCTOBER	OPAL	MARIGOLD
NOVEMBER	TOPAZ	CHRYSANTHEMUM
DECEMBER	TURQUOISE	NARCISSUS

The Months and Their Meanings

The names of the months come from the ancient Roman calendar,
first introduced by Julius Caesar in 46 B.C.

MONTH	NAMED AFTER
JANUARY	JANUS, THE ROMAN GOD OF BEGINNINGS AND ENDINGS
FEBRUARY	FEBRUA, A ROMAN FEAST OF PURIFICATION
MARCH	MARS, THE ROMAN GOD OF WAR
APRIL	APRILIS, FROM LATIN FOR "TO OPEN"
MAY	MAIA, A ROMAN GODDESS OF SPRING
JUNE	JUNO, THE QUEEN OF THE ROMAN GODS
JULY	JULIUS CAESAR, A ROMAN GENERAL AND CONSUL
AUGUST	AUGUSTUS CAESAR, THE FIRST ROMAN EMPEROR
SEPTEMBER	SEPTEM, LATIN FOR "SEVEN" (SEPTEMBER WAS ORIGINALLY THE 7TH MONTH.)
OCTOBER	OCTO, LATIN FOR "EIGHT" (OCTOBER WAS ORIGINALLY THE 8TH MONTH.)
NOVEMBER	NOVEM, LATIN FOR "NINE" (NOVEMBER WAS ORIGINALLY THE 9TH MONTH.)
DECEMBER	DECEM, LATIN FOR "TEN" (DECEMBER WAS ORIGINALLY THE 10TH MONTH.)

Glossary

Autumn. The season that falls between summer and winter. Begins on the September equinox in the northern hemisphere and on the March equinox in the southern hemisphere.

Calendar. Organization of time into days, weeks, months, seasons, and years.

Custom. Repeated practices and behaviors that are associated with particular holidays, places, rituals, or celebrations.

Equinox. The two times per year when the sun's light is directly over the equator.

Fasting. To eat sparingly or abstain completely from food and drink.

Feast. A big, fancy meal that is eaten to celebrate or commemorate an event.

Festival. A time of celebration. May last for several days and be devoted to a specific purpose or event.

Harvest. Mature crops that are ready to be gathered. Also the name for the time of year when this activity happens.

Holiday. A day to celebrate a person, event, or spiritual belief.

Lunar Calendar. A yearly calendar that bases each month on the full cycle of the moon's phases. The Islamic calendar is a lunar calendar.

Lunisolar Calendar. A yearly calendar based on phases of the moon and the solar time of year. Examples: Hebrew, Indian, and Chinese calendars.

National holiday. A holiday established by the government. Often, workers are given the day off to celebrate.

Parade. A public procession to honor a holiday, event, or group of people.

Season. A time period that lasts three months, or one quarter of the year.

Solar Calendar. A calendar based on the seasonal progression as the Earth revolves around the Sun. Examples: Julian calendar, Gregorian calendar.

Solstice. When the sun's light is at its farthest northern or southern point from the equator.

Spring. The season that falls between winter and summer. In the northern hemisphere it begins on the March equinox. In the southern hemisphere it begins on the September equinox.

Summer. The hot season that falls between spring and fall. In the northern hemisphere it begins on the June solstice. In the southern hemisphere, it begins on the December solstice.

Tradition. An established behavior, practice, or action that is handed down and repeated over time. Often associated with celebrations and rituals.

Winter. The cold season that falls between fall and spring. In the northern hemisphere it begins on the December solstice. In the southern hemisphere, it begins on the June solstice.

Illustration Credits

About the Author

Obsessed with books that entertain, astound, and inform, Amy Briggs is author of *National Geographic Angry Birds Space*. A former senior editor with National Geographic Books, Briggs is a freelance writer who has contributed to National Geographic's "Tales of the Weird" blog as well as the humorous Uncle John's Bathroom Reader series of books. Excited by all things trivial, odd, and just plain unusual, she lives in Virginia with her family, who are very tolerant of her Angry Birds habit.

Acknowledgments

We would like to extend our thanks to the terrific team who worked so hard to make this project come together so quickly and so well.

Rovio

Sanna Lukander, Pekka Laine, Jan Schulte-Tigges, Mari Elomäki, and Anna Makkonen

National Geographic

Bridget A. English, Jonathan Halling, Nicole Lazarus, Matt Propert, Meredith Wilcox, Marshall Kiker, Judith Klein, Lisa A. Walker, Anne Smyth, and Dan Sipple